MASTERS IN MODERN ART

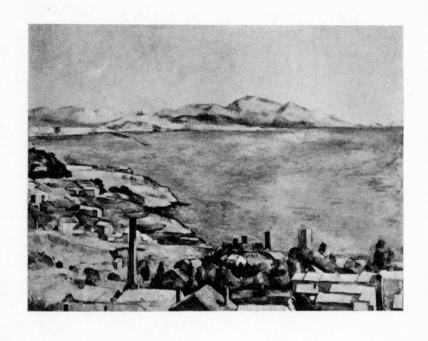

CEZANNE
L'Estaque

MASTERS IN MODERN ART

James W. Lane

Essay Index Reprint Series

BOOKS FOR LIBRARIES PRESS
FREEPORT, NEW YORK

First Published 1936

Reprinted in this Series 1966, 1969

STANDARD BOOK NUMBER:

8369-1332-9

LIBRARY OF CONGRESS CATALOG CARD NUMBER:

67-22100

T O
AGNES

PREFACE

HE modern world loves lists. Why shouldn't it, provided they are short? The much-adduced thirty thousand painters living in Paris are just a fraction of those in the whole world. Even in a country where painting is at such a low ebb as it is in Sweden, there are hundreds of modern painters. All this tangled undergrowth which exists in the world of art must somehow be cut through, leaving us with a vista to the heights.

Yet who will be there, and why? This requires a definition of what greatness is.

Alice Meynell said that greatness in a person meant a great sincerity. Sincerity, in other words, was the least common denominator.

What we must then discover is the least common denominator of greatness among modern painters, and by modern painters I mean painters from the time of Cézanne, who base their work upon certain principles of abstract or half-abstract drawing and design.

Cézanne, for example, was the first painter consciously to destroy the old, accepted conventions of rendering tones and contours photographically or realistically and to apply his own.

By abstract qualities in paintings I mean formalizations. Of course there have been painters before Cézanne who painted abstractly. El Greco was one. Byzantine art, to which El Greco so unconsciously owed a debt, was abstract, and

because it combined with it the emotional and intellectual, it was great art. The greatest paintings have three great elements—emotional, intellectual, and formal.

Now, all modern art is on the whole intellectual, but when I use the term "modern" in this book, I mean painting which the rather conservative general run of people would call modern. Arthur Dove, Piet Mondrian, and Paul Klee are modernists to the core, but without the real greatness of true masters in modern art. Their work has no intellectual content and they paint for the eye as much as Bouguereau and Henner.

Sincerity, as I have said, is the least common denominator of greatness. But there is one more condition. A great painting must have a spiritual quality. It must be experience humanized. The novels of Dickens and Tolstoy, the laments and marches of Tchaikovsky, have this quality, as do the paintings of Cézanne, Van Gogh, and Charlot.

Poorer painters in modern art are mere manufacturers of impersonal arrangements, and no mere arrangements can express depth of feeling, as we see, for example, in the cases of Kandinsky and Miro.

* * * * *

I have therefore chosen as I have these nine leading modern painters because all of them have greatness in what they say and say it in a great manner. Their message is no small exquisite thing, like that of a near-great, such as Marie Laurencin, but a message that has a cosmic import and overtones of almost tumultuous significance. Briefly, their message and their interest are universal.

CONTENTS

Conclusion

ILLUSTRATIONS

MASTERS IN
MODERN ART

PAUL CEZANNE
(1839-1906)

CEZANNE

WENTY-FIVE years ago I doubt whether more than one or two people would have admitted that the wild master of Aix could be popularized. His paintings seemed so queer. There was nothing beautiful (so it was said) in his color. His drawing was like nothing else on earth, and his brush-work was idiotic. The subjects were banal. Who ever saw pears like those in real life or people like that outside of a sick ward?

Well, other times, other customs! In this year of grace 1936 Cézanne still bestrides the art world, as well as the history of art, like a colossus, but the old wild man is tame. At last the work has been sweetened by fashion.

But the paintings themselves have not changed. We can see, after the lapse of years, that it is we who have changed, who have fully responded to the artist's vision. For Cézanne had a great vision. He called himself the primitive of the way he had discovered. And a quarter of a century ago that way seemed very bizarre indeed.

The Impressionists, particularly Sisley and Pissarro, had painted what they saw, toning the facts up or down only in the interests of all-over color harmony. Their best works fell between the impressionism of Giorgione and the fidelity of photographs. If the Impressionists thought of design at all, it came last on the list—which is why, although their pictures still thrill us with their charm of color, they seem

13

somewhat loose and inchoate, as though a nebula were rounding into a vaguely recognizable likeness.

But with Cézanne it was different. The last had to be first. He thought primarily of design. Nor did he mean by design what many of the abstractionists mean by it—namely, pattern. By design he meant (what is the mark of the ideal landscape painter) depth and spaciousness. Yet it is curious to note that to arrive at depth he was forced to adopt a certain type of pattern. His peculiar type of pattern was the way which he as primitive had discovered. Now it is all the rage from art classes to heads of cults.

The way he discovered was the way of the chocolate cake. Just as in the black and light layers of a chocolate cake the light layers seem to recede, so Cézanne obtained depth in his pictures, especially his landscapes, by chocolate-cake design. This was the science of contrasting or complementary colors, and Cézanne knew it, if ever an artist did, backwards and forwards.

It must not be thought that Cézanne made his chocolate cake as obvious as the chocolate-cake stripings on the cathedrals of Siena or Orvieto. His design was much more subtle than that.

Take one of the landscapes depicting the Mont Sainte-Victoire. That bald eminence of Provence Cézanne called his Motive, much as Monet found in cathedrals, haystacks, and pond-lily pools motives for his studies of the various hours of the day. Cézanne must have painted his hill hundreds of times. He was not interested in it from the standpoint of light, but he saw in it great possibilities of design. It was part of the Provence he knew and loved and from

which—except for stays in and near Paris as a student and as a guest of Zola and Pissarro—he never withdrew. Yet many critics have said that his Mont Sainte-Victoire and his Estaque landscapes are just not Provence. They haven't the brilliant light usually associated with the south of France. But Cézanne was an artist, "pure and complex", as one critic calls him, and he found that he could get his effects of space and distance better by slightly greying even the most brilliant of the colors of the Provençal daylight such as green, red, and blue. This he achieved in his later style, for at first he is as romantic and color-conscious as Delacroix.

Those studies which Cézanne did of Mont Sainte-Victoire show that no other painter could make a patch of brown tilled land or a green field next to it sing in quite his manner. This is why, like César Franck's Symphony, such painting gets into your brain and you can't get it out. It is subtle and it settles well. In the "Mont Sainte-Victoire" of the Metropolitan Museum, one of the most accomplished landscapes in the world, there is no great laying on of paint, hardly any impasto, only a slight, smoothened dip of it on the bole of the foreground pine. But by making the color contrasts frequent and short he keeps your eye on the jump and you find that it is led around and finally back into the picture.

To people who cannot like sketches and drawings Cézanne will be forever a closed book. But the triumph of the sketch is that it be able to suggest much in little. Cézanne's triumph lies just there—suggesting to us scores of things.

This is so, no matter by what medium he is considered. The water-colors of bathers and of tree-fronds are the most difficult to approach, for in their harmonies of green, light plum-blue, and pink, varied with a yellow ochre, they are pure pattern. The sprays of tree foliage, as in a water-color in the Bliss Collection of the Museum of Modern Art, are probably the most successful in this medium. But in oils of portraiture, still-life, and landscape, what Cézanne suggests in structure is much.

It was this method, that of suggestibility, of which he became the outstanding exemplar. No artist before him, neither Whistler nor Constable nor yet Brabazon, could touch Cézanne in this. These men indeed were in their small way more delightful and graceful, but their paintings, although they, too, are trying to say a thousand things at once, seem cluttered in comparison with the extreme and majestic simplicity of Cézanne.

The portraits, for instance, seem at first to say so little and yet say so much. Each one is compact of character and vitality, like the *dramatis personae* of Dickens.

One of the portrait gems which Cézanne painted is the "Chocquet" of the Bliss Collection. More than any other of his portraits, it is artistically composed, the red spots on the wallpaper enlivening the background and also the sitter himself, while they balance with the other red on the carpet. The blue grey of Chocquet's hair is echoed by other blue greys in carpet and paintings, while the white of his shirt is balanced by his two feet in white socks at the left and by his folded hands at the right. It is a Post-Impressionistic masterpiece in eighteen inches.

CEZANNE

The portrait called the "Man in the Straw Hat", in the Metropolitan Museum, charged with life if ever a portrait was, demonstrates how its author obtained increased vitality by his palette knife. The knife roughens and scarifies the pigment, but the resultant flaky shagginess fixes the attention of the observer to a virile and alive portrait. The painting is interesting to compare with the Courbet "M. Suisse", usually hanging three or four pictures away on the left. Of course the Cézanne has greater color than the Courbet, for Cézanne is the superior colorist. The great smears of paint on the Cézanne, in addition, catch the light on their bosses and hollows, and rays of it seem to go ricocheting around the sitter's whole face and his hat. The calligraphic line on the profile-shaped lapel of the coat bequeathes much added life to the study. The Courbet, on the other hand, seems but a dull stereotyped portrait, fit to be hung with other celebrities on some dusty wall of an obscure public library or memorial museum.

What gives to Cézanne's portraits their animation? It is certainly not stippling. The pointillism of Signac and Seurat gives a paradoxical effect. Their stippled color merges as successfully into a colored whole as do the color divisions on a swiftly whirled color-top. Yet the curious result of a Signac and a Seurat is flatness, passivity, staticness. Seurat's design—his knowledge of the psychological principles of types of line—brings to his pictures the only life they have; the color spots, if allowed to get the better of his calligraphy, subtract it all again.

Cézanne is an interesting as well as a refreshing contrast. One may compare the effect of his color areas with the

17

effect of those on a *slowly* revolving color-top. Because they do not blend into one another as insensibly as the areas of color do in a Seurat, the function of the eye is automatically accelerated. It is compelled to travel from one long brushstroke to another. The roughness of the palette-knife strokes and the way in which certain minor chords (to use a musical metaphor) combine into majors stimulates the eye and prevents insipidity in the canvas. When color is too perfectly blended, as in the pointillists' work, the eye has little left to do, save to dream of rainbow hues. That is why pointillism is such an excellent principle to use on the design of one's wallpaper and even in some landscapes, but not a good principle to use in portraits that will be framed. The latter demand more form, and even pattern, than pointillism can ever supply.

In his still-lifes Cézanne makes academic paintings look, as Huneker said, as though they had been done on linoleum or papier mâché. Yet Cézanne here paints in a ´smoother style. He has to depend more upon pattern and less upon brushing to attain to form. Occasionally he left a register in the canvas unfinished or unpainted—a conscious or unconscious act which results in a greater ethereality. Form in space was the ideal that led him ever on. He wanted his dishes, his fruit, to have great tactility. He devoted his whole life—hence the innumerable sittings he required for portraits, all those slashed and destroyed landscapes, and the often incomplete still-lifes—that he might eventually learn something about expressing objects in space.

Less than ever in his still-lifes did he care about light. He was far, now, from the luministic pre-occupations of his

youth, being interested, like a good actor, not in spotlight but in the effect he is creating with the rest of the stage. Cézanne most rigidly held to the principle that a canvas is a space to be decoratively filled and if he failed in one spot, he knew the wound would be as gaping as in a jig-saw puzzle with a piece left out. Hence, in doing still-lifes, after he had caught the texture of his fruit, his jugs, or his table-cloth—Cézanne was very eighteenth-century in that —he thought only of how he could fill the rest of his canvas. He found out that if he could prop his fruit up against a background of the most arbitrarily painted color, he could get his best effects, as the still-life in the John T. Spaulding Collection shows. The background is painted with those weeping vertical strokes which make it look for all the world as though it were a first exercise in penmanship. But the color modulates from mauve to aquamarine and ties the color of the fruits together.

Again, a still-life in the Josef Stransky Collection, has an interesting device. The center fruit has been bitten! Imagine how the Academician would paint such. The section so attacked would be painted like the rest of the apple. Not so with Cézanne. He suggests it has been really bitten. The apple so singled out he poses on a plate. The juicy region where the teeth had been merely deepens that effect of actual fruitiness which the other fruits in the composition convey.

Chardin was probably the first intellectual painter of still-life. He took still-life out of the hands of the formalists like Van Huysum and Desportes, who had the engraver's method in such matters, and made it an affair of inter-

weaving patterns as well as the search for form. How large an advance this was is shown by the disfavor and the neglect into which the Chardin still-lifes fell for many years. People did not recognize, even when Manet and Fantin-Latour were painting in styles which, consciously or unconsciously, owed a great deal to him, what a step forward Chardin had taken. Not until Cézanne came upon the scene with his much more intellectualized still-life concepts did critics and art lovers commence to appreciate the new sort of geometry —the sphere, cone, and cylinder theory—with which he wrought his magic. As Huneker put it, when Cézanne painted an onion, you smelt it, and Huysmans, the severe and penetrating critic, said, long before Cézanne's death, he was the forerunner of an entirely new art.

The Cézanne still-life in the Chester Dale Collection is almost a prototype of the twentieth century style in still-lifes to date. The exact balancing of the different objects in color and in position—the subtle occult balances—is the sort of thing which has been much imitated and adapted, with necessary changes, by all other modern painters. Dickinson and Demuth owed particular debts to Cézanne, as they learned from him how not to make a round piece of fruit look like a paper disc. In other words, Cézanne has brought form and order into a style that had hitherto more or less lacked both.

Cézanne has paid for his fame as a painter of still-life. His influence has been gargantuan. A whole swarm of young Cézanne-apers has arisen. The modern still-life, if it is derivative, usually derives from him. And so some people, from tiring of this sciolism of the pretenders, are already

tiring, through an unwarranted transference of ideas, of Cézanne. But you can't keep a good thing down. The very best art has its ups and downs. Raphael gets hit one year, Velasquez another, Monet in yet another. But they all come back. The pendulum, if fickle, is elastic and can be relied upon to fulfill its function as pendulum. Cézanne's still-lifes will yet be as beacons in the art world, when all the burlesques of those beacons are drowned in oblivion.

But it is as a landscapist that Cézanne is pre-eminent and that I prefer to remember him. It has been said that he was the first painter to avoid picturesque and sentimental associations in his work. There are no thatched cottages or classical ruins or "brown trees" in his landscapes. On the contrary, there are sheds and concrete walls and factory chimneys (which add an always welcome perpendicular note) and nooks and corners the artistic value of which nobody else had yet seen.

The two types of landscape in which Cézanne was at his best and which he painted most frequently are the views of Estaque and of Mont Sainte-Victoire. Both of them unroll brimming panoramas and are full of color and space. The Estaque landscapes, in particular, are slabs and shafts of paint merging into each other and making up the strata of his chocolate-cake design. Yet each slab is painted without realism at all. No one could be farther from the fifteenth century than Cézanne.

His landscapes, therefore, are especially abstract. The brushing alone would attest this. Small strokes laid on side by side and graduating, as desired, into the intense tones or into whiteness or neutrality produce an effect of a sun-

flecked rain shower in the distance. Where, again, he uses this method in his studies of trees he is able to imitate the rustling nature of foliage when stirred by the wind. This brushing results often in the weeping quality which poorly laid-on water-color washes have, and yet it dovetails very well with Cézanne's purpose of selection and space-composition. Few landscapists can whittle away so much from their design and remain so stimulating as he.

Cézanne is a remarkable epitome of all good qualities. His landscapes possess color, good lighting, and beautifully registered planes. The trees are always decorative, whether used as set-offs to give the feeling of space or as a study in interlaced design. Fields, water, and distances are struck off admirably, but the most amazing feat is the manner by which both the short- and the far-sighted gain satisfaction —briefly, by his space-composition.

Famous space-composers in the history of art, like Perugino and Tiepolo, appear like mediocre mural painters next to Cézanne. Their works seems in the flat. One cannot feel around Perugino's forms. But with Cézanne one may lose oneself in infinite contemplation of a landscape. The warm reds and greens and browns of his foreground, as in "L'Estaque", contrast so well with the cool blues of the water and the distant mountains. The contrast makes a perfect recession of planes. One wanders in depth and in latitude. Akin to some of the pictures which Berman now puts out, where in a few inches miles of space are suggested, the great landscapes of Cézanne have blazed the way to modern landscape painting.

There are few clouds in the skies of Cézanne and no

interest in cloud-forms. He was too austere an artist to be engrossed in what the Impressionists cared for. They loved clouds, but not for their pattern so much as for their atmospheric value. Cézanne eschews all this. He wants the soil of the fields and the bony structure of the hills to be seen. A man who has the strength to weed out of his painting all the paraphernalia to which smaller natures must cling receives a magnificence which no accolade of fashion grants. Such a man lives by the bare and rugged integrity of his art.

VINCENT VAN GOGH
(1853-1890)

VAN GOGH

INCENT VAN GOGH, one of the greatest painters who ever lived, was one of the few great painters having but small so-called talent. Heightened and fuller meanings came to him from the world he saw. It was no stodgy or pretty place, as genteel water-colors portray it. There was nothing workaday in it for him; it was all excitement.

One can reproduce what one sees by talent. But it requires more than talent to reproduce what is not there, what one sees inwardly; it requires continual or red-hot imagination. Van Gogh's imagination was of the red-hot kind, having been fed on his father's Calvinist theology and having had more practical experience preaching evangelism in the London slums and in the Belgian mines.

The early influences on Van Gogh appear mild enough —Rembrandt, Chardin, Millet, Delacroix, and Anton Mauve, Vincent's cousin. But even when he copied these painters, he added much more than what he saw. His "Pietà" in oil, a copy of a Delacroix drawing in the V. W. Van Gogh Collection, Amsterdam, and his "First Steps" (after Millet) in the Oppenheimer Collection, New York, are object-lessons to the copyist. The ordinary copyist in the museums looks at a work of art piecemeal. He, or she, does not see nor paint the whole as the original artist did, in a burst of inspiration. That is why the work of copyists is so uninspired. Certain colors and lines may be well copied

but the sustained effort and imagination necessary to create a work of art have been prostituted. An inspired copyist following more or less his own bent, like Van Gogh, is a different thing. This is also the reason why, although there are hosts of faked Van Goghs, as J. B. De la Faille points out in his book "Les Faux Van Gogh" (Paris, 1930), Van Gogh can never be really copied. Such originality is utterly inimitable by, which is to say incommunicable to, the copyist.

While his visions were so strong as to make the average man's flesh creep, Van Gogh was nevertheless not getting very far with his art by copying and adapting. He went in 1886 to Paris where he made the acquaintance of Gauguin, Seurat, and Toulouse-Lautrec. Gauguin and Seurat are supposed to have influenced his ideas and his style, but the subjective force of Van Gogh was not to be restrained blandly and in his paintings we see no trace of the influences of these men, except now and then a faint reminder of Lautrec and some small mark of the flat yellow backgrounds of Gauguin.

It is a curious fact that almost all the known great paintings by Van Gogh were done within the three year space of 1888 to 1890. This was the period, climaxed by his tragic suicide, when he was working chiefly either in Arles or in Auvers. Never has an artist so concentrated his output. He usually made half a dozen or more paintings of the same subject, particularly of portraits, boats, and trees. Of his Paris work not much remains. There is the "Père Tanguy" of the Musée Rodin, dated about 1887. This painting reveals Van Gogh's interest in Japanese prints.

Such prints were then very much the fashion for painters and influenced to a marked degree the designs of Manet, Degas, Whistler, Gauguin, and Toulouse-Lautrec. But they interested Van Gogh more from the standpoint of color, and his juxtapositions of sharp color are easily traceable to the Orient. He copied these prints in several works.

But when in 1888, at the age of thirty-five, Van Gogh went with Gauguin to Arles, then only did he begin to find himself. From that time on, for the duration of three precious years, he sloughs off all extraneous influence and becomes himself. Whether with that strange premonition which great artists sometimes have he sensed impending death, or merely because a change to warmer and more joyful climes naturally exhilarated him, he paints now in more furious haste than ever. His unbalance, his enthusiasm, and his temperament, which was a miracle of modesty, became more and more pronounced. Slicing off his ear for a Christmas present, quarreling violently with Gauguin, came easily to this artist of the inner vision. And we are not surprised, since his religion was frustrated and frustration was, as it were, his religion, that he ended up for the nonce in the insane ward of the Arles hospital.

Yet even here the fellow was irrepressible. His painting of the "Hospital Corridor", in a bilious ochre, with one of the inmates skulking by the side-wall, is as horrible as the passages staged in "The Cabinet of Dr. Caligari" and as modern as a photograph by Man Ray. Then of course there is that bedroom picture he did, which may have been of his room at Arles or of his room at Saint Rémy somewhat later. He did the streets of Saint Rémy and though he portrayed

only a few gigantic trees, some bales of merchandise, and a handful of people, the thing is as alive as if the human beings were persons really walking through the picture. Finally he painted the famous "L'Arlésienne" of the Lewisohn Collection and he had the critics and the public staring at last. It is no wonder that to this day the old rentiers and ne'er-do-weels of Arles remember this madman with his momentous imagination.

"L'Arlésienne" is one of the majestic portraits of the world. The livid yellow background, comprising almost half of the painted space, the red chair, the sitter's blue dress, the bright green table at which she sits mulling over a red and a green book, her face the color of a mud-pack standing out against that livid yellow—all these first, and at the same time final, impressions I shall never forget. Nor will the world.

Van Gogh's stature as a portraitist fortunately does not rise or fall with this work. Other portraits of his, such as the Chester Dale "Mlle. Gachet", the Detroit Institute's alternately called "Self Portrait in a Straw Hat" or "Portrait of J. McNeill Reid in a Straw Hat", and the "Zouave" in the Walter Sachs Collection, attest his genius. The Detroit work as well as the "Postman Roulin" of the Paine Collection in Boston shows that he had been also definitely influenced by Cézanne, who lived in the vicinity of Arles and whom he met. The short, "weeping", impasto-laden strokes are similar, but his method of posing the sitter is more dynamic than Cézanne's.

Dynamic is of course the word that fits Van Gogh to a T. His portraits have it, his street-scenes have more of it, while

his landscapes, trees, and still-life have it most of all. They fairly quiver with nervous tension.

I used to think, and I still do, that motion in art is often very unattractively designated. I found it so in Rubens, whose *brio* disturbed me from true appreciation of the merits he undoubtedly has. The trouble, I believe, lay in the fact that the movement in one section of a painting by Rubens was not harmonized with either the motion or the calm in other registers of the painting. The moderns order this better. If movement, a breeze, a storm, or other excitement is to be painted, the whole design is keyed to that pitch. Prior to Van Gogh, only Turner and Delacroix or Courbet could do this really well. That is why, although up to a few years ago the style seemed outlandish, Van Gogh has taught modern painters, Vlaminck in Europe, John Whorf and Burchfield in America, for example, a whole bag of new tricks.

No wonder painters of more conservative storms, like Jongkind and Legros, might look askance. The power of Van Gogh's paintings took some time to charge the public with its energy. But a real revolution in taste ensued when his work could be seen as a whole, and there was—in this case—no more chance of turning back the hands of the clock than there was of stemming the play and flow of the ocean.

Indeed Van Gogh's technique not infrequently resembles the ocean wave. The lofty roll of the design in his "Sunset Over Ploughed Field", in the Oppenheimer Collection, is oceanic. The greatly increased movement in canvases like the "Cypresses" or the "Houses at Auvers" (in the Spauld-

ing Collection) remind one of water in turbulent state. That they have this all-over harmony is proven by one's feeling that moving water is one of the few epithets which can be applied to their spirit.

Mere restlessness in art is no novelty, even to the moderns. But Van Gogh had more than mere restlessness. No matter how dynamic he may be, he does not fail to be ultimately soothing.

Take so moving a picture as "The Gardens of Arles" in the Arthur Sachs Collection. The bristling, Prendergastian impasto, made up of, as it were, iron filings partly drawn together by a magnet, forms a rustling arbor of paint below which the loiterers in the walk rest. Here in the walk the perspective is as conventional as could be wished. But the latter is a point of rest technically for the former and the picture is rounded out into a well of delight.

Or consider "Les Oliviers" in Mr. Chester Dale's Collection, a charming landscape in soft colors of green, mauve, and pink neutralized almost to grisaille, which calms the flamelike brushing of trees, figures, and clouds.

Most charming of all in technique, color, and loveliness are the still-lifes of Van Gogh. Of them I feel so strongly, that they might be nearly profaned by my description. Let them then be described by another. As Julius Meier-Graefe says, "Many of Van Gogh's flowers are like seascapes whose waves have become leaves." And he adds that Vincent's flowers are as much portraits as the portraits of Rembrandt.

The "Sunflowers" of 1888, in the Tate Gallery, is a tour de force in yellow, and a yellow which has approximately its value in nature, Van Gogh being one of the few painters

in all history who has had the presumption to dream he
could equal the tones of actuality. Again the use of the hot
yellow background, throwing the foreground flowers
(which are of course also yellow) into high relief and
accentuating their color—an inspired method! The contour
line marking the edge of the ochre table against the yellow
wall is drawn in a purple. Again an inspiration—no other
color could have served so well.

In the Louvre, painted also in 1888—as one by now
would easily suspect, there is another wonderful still-life
of "Flowers in a Brass Vase". Here the palette chosen has
been quite different. A gray-blue background studded with
flakes of white paint results in a starry-sky sort of appear-
ance, against which is placed the brass vase with its glitter-
ing high lights. In the vase are orange-red flowers the tones
of which resemble those of tiger-lilies but the petals of
which are similar to harebells. This is a most gorgeous
composition and oscillates with that type of refracted light
or glare which is characteristic of Van Gogh and his paint-
laden brush.

One other marvel of flower-study should be mentioned
and that is the "Iris" of the Jacques Doucet Collection.
When I first saw this canvas, in the Museum of Modern
Art, I forgave all the faults I thought I had seen in Van
Gogh up to that time. His irises had that wild, woodsy
thickness of flowers planted in profusion by a generous
gardener—a thickness seemingly dependent upon planting
by row on row, but actually upon the subtle art of the
cultivater. All this—and more, too, such as the wind-stirred
flowers themselves—Van Gogh conveys on this picture. The

color is of the most enchanting: violets, whites, and greens predominating and wooing the spectator to the limit of his senses.

There was a galaxy of fine flower painters in Van Gogh's generation. Manet, Fantin-Latour, Monet, Degas, Renoir, and Redon are exquisite artists in the mastery of flower technique, but I think it may be said that Van Gogh had more sheer power and vitality than any of his coevals. The truth is that one does not so much take one's hat off to Van Gogh when one looks at a single canvas unsurrounded by those of other painters. One rather takes off one's hat to Van Gogh—and very hurriedly, too—the moment flower pieces by other men are brought into the same room for comparison with his. His make most of the others look timid and *wilted*.

Whatever adds dynamism to a painting, we may be sure, then, Van Gogh never overlooked. His half-stippled technique of impastoed strokes always assured some strength. But he varied the type of stroke according to his subject. We have noted the flaming swirls he used in the "Cypresses" and other well-plastered canvases. In one of the rare fruit pieces he did, such as the study in the Brewster Collection, Chicago, he builds a sort of nest or halo of impastoed luminosity around his fruit. Thus the idea that they are luscious and have been born in sunshine *is* carried as in no other way.

Van Gogh was also fond of boats—as fond of boats as Renoir was of little girls. Boats, unless one handle them with the scallop-shell lightness of a Dufy or with Joubert's and Asselin's emphasis upon rigging, are not apt to give

dynamism to one's composition. But Van Gogh mastered the dynamic force which came from certain arrangements of boats in parallel perspective. Granted that such arrangements might have such force, they certainly had artistic appeal. Van Gogh again found the inspired combination. After him perspectival pedantry, as, for instance, Lalanne had been compelled to teach, was no longer warranted. The painting, in the Knoedler Collection, of rowboats moored together, which he painted at Arles, is a gay, refreshing masterpiece, as is that of the multi-colored boats drawn up on the beach with some sailing away, entitled "Bateaux, Saint Maries", now in the V. W. Van Gogh Collection. Finally, "Les Debardeurs, soleil couchant, Arles" (in the Ackermann Collection), a canvas of larger boats tied to a wharf, with a blood-red sunset in the distance, has twice the force of the most forceful Jongkind.

Van Gogh at last left Arles. He made a short stay in Saint Rémy and then settled under the care of a Dr. Gachet at Auvers. Here in 1890, after painting numerous landscapes and other masterpieces, the oft-imputed influence of Gauguin upon which I do not see, he shot himself. Mischievous townspeople of Arles used to throw themselves at him in order to see him fly into one of his violent rages. But he never hurt them during a fit; instead, he would tick off a chef d'oeuvre. A curious commentary upon the powerlessness of communities to think is that even today at Arles those old men who remember Van Gogh will speak to you only of the peculiarities of the man and it will be you who will have to remind them that their little town once housed a great painter.

For great painter he was, in spite of all the rationalists and reactionaries who call him a dauber, a loon, or a strident emotionalist. In the last analysis he shows them up. He also applies the acid test to each one of us. If some observers still do not care for him, it betokens rather a hitch in their own development than any error of Van Gogh. He is accepted now by the art world, since those most readily won to his spell were and are the artistically-inclined. The amazing number of forgeries committed in his name and seemingly outnumbered only by the forgeries of Corots strengthens every argument as to his greatness.

With Cézanne, Van Gogh has led to all the movements, developments, and celebrated painters of modern art. The path of Cézanne narrowed logically to the cul-de-sac of Cubism and then to that, on another fork, of Purism and Surrealism. Cézanne favored the built up pictures of the theorists and eased the way to Braque, Léger, L'Hôte, Picasso, and Derain. The path of Van Gogh—the path of impulse, freshness, and romance—led to the school of spontaneity. Against the theorizings and the advice of a teacher-theorist like Ozenfant can be put Van Gogh's belief that if you paint as you feel, there is no need of lessons, theories, or credos, or even talent, because you have something to say and some urge to say it artistically. Here, under this banner, we will find anything purely decorative, from the décor of Matisse and Dufy and the force of Rouault to the visions of Chagall and the stormy charm of Vlaminck and De Segonzac. The most advanced of the Surrealists, like Max Ernst and Paul Klee, owe their spontaneity to Van Gogh. For, although compared with them he may seem old

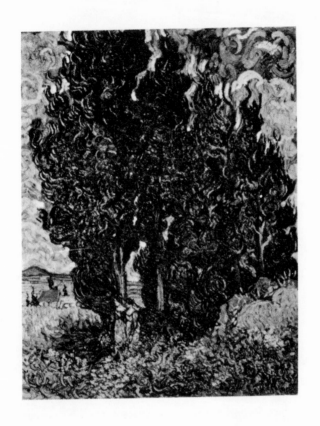

VAN GOGH
Cypresses

hat, in him is the grain of their own philosophy: to be, as Ozenfant says, "perceptible subliminally". If these seem tall words, let us remember that Van Gogh, who as a deeply religious man was an anomalous suicide, had the mysticism of an imaginative and ardent child. That alone, coupled with the successful and strong manner in which it found its way into paint, should make him worthy of our respect and admiration.

PAUL GAUGUIN
(1848-1903)

GAUGUIN

THE stature of Gauguin, more than that of most other great artists, remains engagingly constant. Consider him from the facts of his life. Here is the son of steady bourgeois parents, father Parisian, mother Peruvian, who plies the stockbroker's routine in Paris for twelve dreary years and paints on spare Sundays. But he makes his "pile"—stock-broking, and then chucks that job for good. He can paint now!

But in two tiny years he is poor again and to keep body and soul together is forced to get work at pasting posters on buildings at three and a half francs a day. Two years more see him selling all he possesses and clearing out, with a friend, to Martinique. Here he only just begins to find himself, to discover the exotic colors, the Persian-carpet colors, that signalize his work, when his money gives out and his friend attempts suicide.

Gauguin comes home, but with less success than ever as a painter. He has exhibitions, he develops his theory of Synthesism at Pont Aven, his pictures will not sell. In despair, in 1891, he determines to leave France for ever. A sale of his pictures—thirty were sold—at the Hotel Drouot nets him not quite a poor ten thousand francs, and he leaves directly for Tahiti.

Did he know that Tahiti and the South Seas were in the air? Stevenson was in Samoa, La Farge and Henry Adams in Hawaii. These virgin lands, so restful to the tired sons

of civilization, because the people in them were at once primitive and, as La Farge thought, Grecian, beckoned to Gauguin with an imperious gesture. Perhaps he could find himself out there, another member of that late nineteenth century movement to escape from the trammels of refinement and the dogmas of super-aesthetes.

The seriousness, the intellectuality, of the Impressionist Movement had palled on him. He wanted simple sensation in a landscape of classical, because unruffled, nobility. He wanted to work out the ideas of Synthesism which he and other painters of the Pont Aven group had propagated. That is, he wanted to order all of his pictures as to color. Establishing a luscious palette in which the blue-violet of Concord grapes deliciously smudges the composition, with greens and reds freely used but not in the ascendant, he painted large canvases where the color areas are broad but where every tree branch and flower seems rooted in the logic of nature. It was the type of art that led, and should have led, easily to mural decoration. It looks as though largish areas of a painted concrete wall had been chipped off and put in a frame.

In actual fact the best criticism of Gauguin has been handed down by a famous mural painter, Maurice Denis. Denis said that

> "In the land of tropical sunshine where he (Gauguin) lived he did not translate the brilliant contrasts of light and shade, but rather profited by the serenity of the atmosphere to equalize planes and tones and suppress all aerial perspective. . . . His pictures are genuinely level surfaces on which

42

are balanced decorative strokes."

But Gauguin himself did no murals, except what he may have painted in the cafés of Pont Aven. We may wonder at the luminosity of a painting like the "Ia Orana Maria" of the Lewisohn Collection and we will probably not have our clue until we connect it with Gauguin's known interest in stained glass or in the broad manipulation of surface design, which has been the justifiably aesthetic ideal of certain modern art classes.

If in our peregrinations through the galleries and collections of the world, we have always been accustomed to look for plausible *forms* in a picture, the lack of them in many Gauguins is one of the first things we shall note. We may say to ourselves that a man who could not draw nudes *à la* Couture or Cabanel or Ingres has no right to a heritage in art history. But we will very soon forget this as the impression of gorgeous color mounts to our heads. In racking our brains for a comparison, we will probably at first get no farther than saying that sometimes the Impressionists, and sometimes Constable and Delacroix, seem to suggest a faint resemblance to it. But it is only the faintest.

Imagine Constable saying that to paint the green of the grass you must lay on the green paint pure from the tube. And then recall Gauguin's statement that a meter of green —which is possibly six times as much as Constable ever used in one place—is greener than a centimetre, and you will see the enormous difference. Gauguin played with huge patterns in his canvases and therefore required huge color areas. We can see that clearly.

Why did Gauguin use the colors he did? He was a

romantic. Now and then, in the toga-ed draperies of Poussin, arch classicist, we get a sense of the color values of juxtapositions of primary colors in large areas. But the colors are not so interesting nor so stimulating: neutralized lakes and blues, whites and yellows. In contrast, Gauguin has the modern man's knowledge of the supplementary colors. In the "Ia Orana Maria", as often elsewhere, he uses a white pattern on a red dress in the foreground figure and a yellow design on a blue dress in the background figure. This buoyant color scheme is varied in Gauguin's work with more subtle values, like the study in reds which he used in "The Bathers" of the Lewisohn Collection. And as Sir Charles Holmes warningly points out, Gauguin, who often signs his canvases "P. Go.", could be just as subtle as possible. His "metre of green" statement has been almost a misnomer, for careful study of a good Gauguin, such as "Les Tahitiennes" in the William Church Osborn Collection, shows that there is very much gradation in his colors. Because his color area is large and flat and brilliant does not mean that there is no modeling from light into shade.

When I first looked at Gauguins, it was my impression— as I am sure it must be that of the ordinary man—that there was no meaning to be found, save only the meaning of not-meaning. A Gauguin is nothing but glorious color and intriguing pattern. Gauguin was not interested in any other technical matter. He had studied Japanese prints, Byzantine art, stained glass, and Persian patterns, and they developed him strongly on the aesthetic side. His pictures generally tell no story and generally are unliterary.

44

But the color which informs them is unforgettable. What if it is, on the whole, the color imported from another art —that of stained glass and that discoverable in the Ferraghan rugs of Persia, with their deep, dull purple, old rose, green, and ochre? The study of medieval stained glass also lent Gauguin the idea of breaking up his composition into separate forms, often like jig-saw cut-outs. That marvelous Tahitian painting of his, "The Day of the God" (in the Birch-Bartlett Collection at the Art Institute of Chicago) shows the natives dressing by the swimming-place. Their clothes strewn along the sand look less like clothes than anything else you can imagine. They are amorphous objects and lie as flat as pancakes. But in one heap of clothes a navy blue is painted on a tomato red and the red lies on a cerulean. The observer doesn't care whether or not Tahitians really sported such colored clothes. He is entranced by the artist's sort of reserved joy in playing so tastefully on the chromatic scale.

If Gauguin's palette of green, purple, and old rose, despite being varied occasionally, as in the Lewisohn Collection picture, with blues and yellows, or, also occasionally, as in "The Portrait of Meyer de Hahn", with Van Goghish oranges—if this Persian type of palette seems monotonous, remember, too, that it is cooling and restful, as old rugs are. Think of the purples being so modulated from red-violet to light blue-violet and deepest purple as to create a chain of color tying together the different sections of the canvas.

The Gilbert Fuller Collection in Boston holds the admirable "Under the Pandanus", painted in 1891, just after

Gauguin had reached Tahiti. It represents the height of his powers as a Synthesist, the result of his work at Pont Aven in Brittany the three previous years. Here the groves of blue-violet tree trunks on either side of center—one speaks as though one had stage-directions in mind, but modern painting is as openly or subtly organized as a stage-setting—are roped together by a sinuous line of old rose in the front center, a path running beneath the trees. The painting has no story to tell, no ax to grind; it merely shows how one artist, preternaturally gifted in a color sense, played with the particular colors he used, the Persian ones, as though he were the master of a most sensitive harp.

In days when my own color sense was perhaps less attuned, Gauguin's choice of a bilious greenish-ochre in which to render the tones of the human body worried me. Even admitting that the Polynesians, among whom he spent ten out of the last twelve of his fifty-five years, have dark bodies, they are hardly this color. La Farge painted them in his water-colors more according to fact. The yellowness of a ginger-bread cookie seemed to me hardly appropriate either for Polynesians or for religious sculpture, such as that shown on roadside crucifixes. Yet Gauguin's yellow ochre dismays me no longer, for you will find it, too, in Persian rugs. Why should a painter, you ask, paint like a rug-maker? I don't know, except that painters, always on the look-out for new techniques and in deadly fear of being bored, thought that a different art with its different colors might imply, or offer, something new. The rugs of Persia in their patterns bespeak subtlety and exoticism, and though exoticism is often not primitive, like Gauguin's, its rich

colors go well in romantic painting, which Gauguin's certainly is.

Undoubtedly his love of colors had been developed by early travel. He may have remembered his very early childhood in Lima, Peru, where he lived, after his Parisian father's death, with his mother's people. Then, brought back to France, he had his boyhood's education there. At the age of seventeen an uncontrollable wanderlust seized him and he shipped to sea as a pilot's apprentice on a ship that made the trip to Brazil. For three subsequent years he was in the French navy.

All these voyages must surely have had an effect on a nature already strongly sensitive to beautiful color. But the young Gauguin, when twenty-seven, judging from the landscape of those years, the "Snow Scene on the Seine", well-designed but insipidly Impressionistic, was not a painter of any unique promise. He was literally too much of an amateur, a collector, a stock-broker.

After that, the deluge. The man begins painting in earnest. It was in 1883 when he gave up his stock-broking. He lives for his art, which at first is influenced by the weeping brush-strokes of Impressionism (due to his friendship with Pissarro), and then, breaking with the Impressionists, creates its own original forms. First, he makes the Martinique trip. Then, back in a year's time, he develops his ideas of Synthesism at Pont Aven and hobnobs for a month with Van Gogh at Arles. His Paris shows were unfailingly failures and in 1891, as we have seen, he decided that "civilization" was no place for him and moved out — Tahiti-wards. But he was back in two years, a-weary of this

wicked world, to sell all his paintings and clear out to Oceania for good. After a trip north to Copenhagen (his wife was Danish and lived there) to say a last farewell to her and his four sons, he set sail once more for Tahiti in 1895.

From then until his death in 1903 his life was just one long round of battling with the law, French government officials in the island, and the police. He attempted suicide and, battered and dismayed, finally died in 1903. The wonder is that he produced so much, although 1902 was a good year unmarked by wranglings. About then he accomplished some fine still-lifes, which, if more stolid than Cézanne's, are well "realized". In them Gauguin's fondness for mauve and red-violet — a fondness that Matisse picked up (for Matisse was likewise influenced by Persian colors as well as patterns)—stands out.

Yet once the observer has seen a few Gauguins he will never mistake a Gauguin for anything else. In truth it must be admitted that Gauguin is a bit monotonous. He has not the variety of a Van Gogh or a Picasso. But his singleness of purpose was devoted to featuring the life he thought a romantic should live.

It is one of the curiosities of history that at the end of the last three centuries there has been a definite return to the simplicities of nature. First, Swift at the end of the seventeenth century took up the cudgels for an existence passed in exotic lands, just as Herrick had sung of the Hesperides at the beginning of that hundred years; then, at the close of the eighteenth century, we had Rousseau, Chateaubriand, and Ossian; and at the end of the nine-

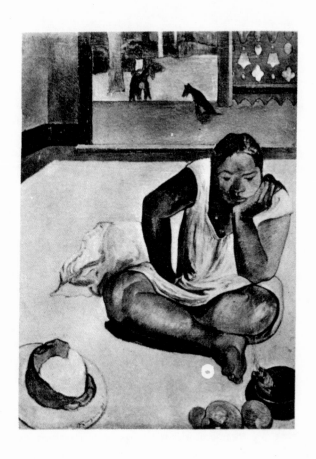

GAUGUIN
Woman Seated

teenth, Loti and La Farge.

The "noble savage" was always contrasted with the corrupt white man. He was supposed to be healthier, being in a state of nature. Therefore we should emulate him, wear no clothes, and let our own morals wander as they list. The creed was perfect romanticism and perfect naturalism. It was what Professor Tinker of Yale has called "Nature's Simple Plan."

With the Polynesians such naturalism was moralism. But with the white man the creed was all right as long as it remained mental and nostalgic; once he practised it in the flesh, it led to immoralism and nudism.

Gauguin helped to bring in an appreciation of the aesthetic side of primitive civilizations. It was real pioneer work then. We knew little of Persian art, less of African, and nothing of Mayan. What we have gleaned from the latter two we have gleaned in part from the work of Matisse and Jean Charlot.

Gauguin's stamping-ground was Tahiti. His paintings of Tahitian natives and his green-and-plum-colored landscapes have much the same sort of overtones as Debussy's "Après-midi d'un Faune". They preach the moral of sweet dalliance in ideally decorative surroundings.

HENRI-MATISSE
(1869-

MATISSE

ATER'S statement that all the arts aspire to the condition of music is well borne out by the case of Matisse. For this French painter is a master of pigmental counterpoint. His compositions are impelled by a balanced rhythm of line and color or else, more commonly, they sing with the most intricate system of color-relations, one melody of color echoing another, that has yet been devised for modern canvas.

Matisse has been called the most important living painter, and it is true. He is important on account of the wonderful erudition and resourcefulness which have given him a command of expression few painters today can equal. But his command and control of pictorial means bespeak a marvelous technician, a technician, however, who has something to say.

Grace is the charm of Matisse. He always thinks of a canvas or a sheet of paper as a surface to be gracefully filled. If it is of one size, one type of drawing will be appropriate; if it has vastly different dimensions, Matisse will vary the rhythm, size, spacing, and color of his composition accordingly. His sense of proportion is remarkably right, and a sense of proportion rarely fails to endue whatever it touches with grace.

The grace of Matisse's work is more than half an oriental grace. He early became interested in Japanese prints. Artists whose influence one sees in his work—Manet, Van

Gogh, and Gauguin—had already been profoundly affected by them. Later, in 1903, he had occasion to study the Mohammedan Exhibition in Paris where he gained first-hand knowledge of Persian rugs, miniatures, and pottery, and Syrian textiles. The approach to such oriental sources has given his work a two-dimensional quality. Having the flatness of surface of eastern art, it lacks the dimension of depth, the quality of tactile values. Some will say, admitting Matisse has so many of the attributes of a great painter, more's the pity; but one must realize that his art could not express what it does with the more occidental dimension. There are a few Matisses, like "The Windshield" of the Kraushaar Galleries, which give the appearance of probing into deep space, but the effect comes rather from perspective and set-offs in the foreground than from modeling. In modeling itself, Matisse, save in some of his drawings, has never been interested. That is why some of his nudes or dressed figures look like crumpled marionettes thrust aside into a corner. They are no more like the odalisques of Delacroix than black is like white. But note that the form is inseparable from the design of the picture. I think one acutally gets a much greater exotic feeling from a Matisse interior with one woodenish odalisque than if Delacroix and Ingres had striven to paint the Sultan's harem all their lives. And that is just what Matisse is after—the spirit of things, the *genius loci*.

The spirit of a place is undoubtedly difficult to capture if one wishes to capture it, as Matisse does, under the form of eternity. Easy, comparatively, is the capture under momentary aspects, such as the Luminists and Impressionists

achieved. But Matisse gave himself the harder task of rendering feeling with a sense of durability. Let him tell you how he does it:

> "To paint an autumn landscape I will not try to remember what colors suit this season, I will only be inspired by the sensation that the season gives me; the icy clearness of the sour blue sky will express the season just as well as the tonality of the leaves. My sensation itself may vary, the autumn may be soft and warm like a protracted summer or quite cool with a cold sky and lemon yellow trees that give a chilly impression and announce winter."

In brief, he is trying to render autumn—not the autumn of any particular place or even of any particular hour (he is at the opposite pole from Monet), but one of the universal feelings which autumn inspires. If his trees seem to be stylized, as trees are in Chinese paintings, it is because the trees of Chinese paintings that he studied stand for the spirit of tree-dom and enable Matisse, when he uses similar forms, to express the essential, universal feeling of a landscape.

The various landscape studies he did in his gay and decorative period of feathery lightness (1917-1925), when he was painting a great deal at Nice, a period that to me is the finest of all through which he has passed, show a certain dependence upon Chinese form and Cézannesque depth. But Matisse, not being interested in how far you can see, like an Umbrian, into the background, draws the curtains of his stage ever so slightly, lessening the aperture of

the view. There is less panorama in a Matisse than in a Cézanne, but more motion. His tonal relations are more subtle, as befits the almost greatest living colorist. Examine the "Villa Bleu" of the Chester Dale Collection, with its lovely neutralized yellows and blues, and also the "Olive Trees" of th Cone Collection in Baltimore and you will see that the whispering leaves of the trees are entirely a-shimmer with color.

Such playing with color has perhaps never before been seen in the painting of a westerner. Just as you would modulate from minor to major chords on the piano, so Matisse uses strident colors here, re-echoes them mildly and touches in with softer tones there. A lavender in human figures (and Matisse is a master of lavender) is picked up by a softer lavender, painted in a different way, on a tree. All of which soothes the eye as a Debussy nocturne the ear.

Next to color, design is the greatest element in Matisse's repertoire. In fact, if one consider only his drawings, which are uncolored, design, I think, will be admitted as his major plastic value. He goes figuratively all through the East—from Egypt as far east as China and Japan and as far north as Persia and Russia—to get it. He filches most ethically, for he recreates what he filches. Rosettes, arches, arabesques, tiles, stripes, and many sorts of other decorative motives abound in his works, until various canvases resemble a mosaic, a tapestry, a bouquet, a pattern of lozenges, a poster or even—as is suggested by the lovely still-life Mr. John T. Spaulding of Boston owns—a brightly colored American flag! Such are some of the stylistic means used by a fertile brain in its quest for thematic creation.

MATISSE

People use the phrase "derivative painter" a little mock-
ingly. But it all boils down to whether such a painter can
derive something from the art from which he derives. To
have a vocabulary is not a remarkable thing. It is a neces-
sity, without which one could only stutter. What matters
is the use to which the vocabulary is put. Matisse is un-
approachable in framing a very erudite art from traditional
sources. He has a rich vocabulary. After all, a painter must
get his ideas from somewhere. Even the most original
painters, the Blakes of the world, lean heavily on something
or other, with Blake, on Holy Writ. But if a painter can
impose upon his borrowings a fresh spirit, a new point of
view, or show a novel technical mastery, so that, for all our
own ability to penetrate it and say this came from here, that
from there, one can declare it looks as if in nobody's style
but his own, if, in short, it stands out like the first star
in the sky at dusk, then we forget his derivations. Matisse
is a painter of many styles but of only one point of view.
Picasso, in contradistinction, is a painter of many styles and
of many—shortly-held and poorly-digested—points of
view. Matisse, it has been remarked, is still painting in
1932 subjects whose import is similar to that of those he
was painting in 1905, the year in which, exhibiting at the
Salon d'Automne with Marquet, Derain, Vlaminck, and
Rouault, he was dubbed *fauve* and his paintings became a
matter the art world could not disclaim.

In a way, Matisse has been more self-reliant than Picasso,
the eclectic and uneven Spaniard. Outside of his first ten
or fifteen formative years as a painter in which he mimicked
Chardin, studied Turner, and was instructed by Moreau

and Carrière, few or no extraneous influences (except the oriental ones) are discernible in his work. He never was a Cubist; he never was a Surrealist. It is less than accurate to call him a Post-Impressionist. The Monetesque "Dinner Table" of 1897, in Dr. Friedmann's Collection, Berlin— one of his earliest paintings, since he only forewent the law as a profession in 1893—is a masterpiece of luminism, of "open-window" painting, and of the *trompe l'oeil* technique, sprightlier than an early Degas and more detailed than most Renoirs. The glorious "Pont Saint-Michel" of the Knoedler Collection, done in 1900, in its strong color flatly laid on and in contrasting areas, hails from Gauguin. But, of these paintings, the "Dinner Table" was only a stepping-stone, from which, when it unleashed a thunderstorm of providential abuse from the critics, he went on to develop his own style. And the "Pont Saint-Michel" style he only used for the mural decorations he did with Marquet for the World's Fair of 1900 in Paris and never reverted to it.

As a thinker on aesthetics, Matisse has asserted that there are no new truths, only new aspects of old ones. He defends his variety of style—now greyed or browned, now colorful and elaborate, now abstract and austere, now decorative and insouciant, and now with various opposing qualities combined—by telling us that his destination is the same but that he finds he must have different ways of getting there. His destination, of course, is expression, or, his feeling for life.

While Matisse becomes in his later work probably the best harmonizer of modern painters, his first fauvist work

58

was more concerned with rhythm. The "Joie de Vivre" in the Barnes Collection at Merion and "The Dance" of the Museum of Modern Western Art, in Moscow, illustrate his theory, explained again in his "Notes of a Painter", that the most violent and precarious positions in movement may be expressed by abridging and condensing notation in the interests of balance. For once balance is established or re-established, a sense of duration, as Matisse says, is suggested.

These particular paintings of nude studies are the acme of composition. One may speak of them as Matisse spoke of Cézanne, from whom he conceivably learned—he had bought early in life a Cézanne "Baigneuses" for his collection—how to avoid confusion in drawing many nudes together. What he was after was the essentials. Whether in the austere linear compositions which he made in the abstract period (1913-1917) following upon his fauvist experiment, or in the coloristic harmonies that I have already compared to musical chords, which he practised in his gay style of 1917-1925, Matisse stresses essentials. He is not willing impressionistically to reflect momentary sensations. He wants to seize upon the durable that lies underneath the superficial. For this reason he is constantly retouching, both in line and in color. Above all, he wishes to be true to nature and he is not ashamed to admit that copying nature, with the changes, embellishments, or simplifications necessary for better interpretation, is the test of artistic sincerity.

Matisse feels most sincere, by his own confession, when he draws the human figure. It will be noticed that through-

out his work there are more figures than anything else, just as in the work of Marquet there are less figures and more landscapes. Matisse speaks of his almost religious veneration for the human figure. It will also be noticed that admiration of the human figure does not lead him into portraying much facial detail. He prefers to treat the figure impersonally as an element of composition, but when he does get down to traits, as in the famous "Young Sailor" of the Seligmann Collection, Berlin, or in "La Jeune Femme Accoudée" of the Lewisohn Collection, he gives the face dignity and seriousness. Distortions are used but only for linear intensity and rhythm.

Let it be granted that Matisse paints, in general, non-naturalistically. He never, in his portraits, tries for likeness or representation of character. You, the spectator, are to regard the canvas as a picture, as an exercise, if you will, in design, pattern, or color. Though you may be reminded of the portraits from Egypt or of certain of those by Monet, Cézanne, or Modigliani, you will think chiefly of the cretonne effect of the dress and of how well various colors in the face tie in with those elsewhere. The background may be a Gauguinesque livid canary yellow, not at all similar to the background of usual portraits and the whole dress may be most un-occidentally diapered into a lozenge pattern. But you have a picture, enchanting in color and winsome in design.

Completely through the gay period of 1917-1925 it seems to me that Matisse was turning out masterpieces. His "Anemones and Mirror" in the Phillips Memorial Gallery is a work of beautiful tonal relations, pinks and greens and

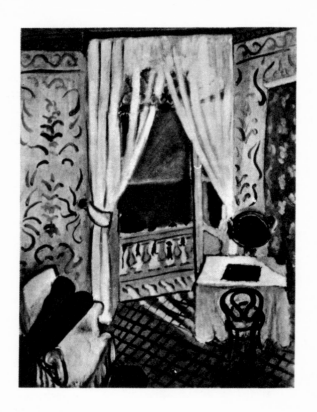

MATISSE
Interior

mauves and crystals singing against the black background. Actually no other painter can give to mauve quite the undertones Matisse does. In his interiors, particularly the studies at windows, he communicates, as no other painter, that claustral, heat-laden atmosphere behind closed shutters which Proust caught so well in the first volume of "Swann's Way."

A course in studying the gay period of Matisse should be a pre-requisite for interior decorators. Nowhere so much in painting will be found that freedom from primness and overbearing theory or that alliance between perfect color harmonies and rhythmic design which escapes all imputation of artificiality and premeditated effect. The "Meditation" of 1920 is a splendid instance of contrasting design, while "The Moorish Screens" of 1922 and the "Pink Table Cloth" of 1925 in the Lewisohn Collection, and many other canvases of later date, show Matisse's love and decorative arrangements of circles, squares, checkerboards, and lozenges. His odalisques and still-lifes exhibit the greatest powers of elaboration and synthesis. Luscious color, dovetailing rhythms, and sophisticated design are earmarks of a nature sensitive to grace, dignity, and charm.

Values such as these constitute Matisse's point of view. His slant on life is not reportorial. Think of his paintings as pure pictures, for remember you are studying an artist than whom no one understands better how to "bring to life the space which surrounds" a drawing. Remember that the painting in his paintings is perfectly placed. His line has none of the heavy-handedness to be seen in some modern American canvases and his subjects, while not so carefree

as Dufy's, have usually an equal lightness of spirit. His sculpture is of serious merit and as a color harmonist he is in a sphere apart. Whatever he does, sings. Pater could ask no higher devotion to art.

JOHN MARIN

(1870-

MARIN

OR many people, I should suppose, love of John Marin's water-colors is an acquired taste. The love came on me that way and as I know one or two men who still cannot abide them, the taste for these delicacies, if it comes, will necessarily be acquired. Yet acquired tastes in art are somehow less suspect than natural ones, provided snobbery and sophistication do not overrule reason.

I think that if Marin's early water-colors and etchings—the work he did abroad, of the Seine and of the Tyrol, before 1910—were made more available, the public would delay less in appreciating him. This early work is definitely like Whistler's, not only in the etchings, with their refined lines reinforced with tone but also in the water-colors, as in that of the "Girl Sewing" (of Alfred Stieglitz's Collection), where, hidden in swirls of misty, diaphanous touches, the subject may not appear at first glance. But then, as it comes out of the luministic technique, what a thrill! Is not this what we experience before those marvelous Whistler water-colors and pastels in the Freer Museum, Washington, as before the similar technique of that rare Victorian painter, Hercules Brabazon, much collected by Soames Forsyte in Galsworthy's saga?

Well, you have to have the riches of Soames to collect Marin in these days. The museums as well as the private collectors were slow in doing it, until by now Alfred

Stieglitz has a corner on the market. Brooklyn, Columbus, the Metropolitan, the Whitney, the Museum of Modern Art, all own Marins, but the Marins in each museum of the country average about one. The museum directors held off too long. Now good Marins—I will not say for museums, which are entitled to lower prices, but for private collections—command anywhere from five to ten thousand dollars. And Mr. Stieglitz has, at An American Place, his gallery in New York, bins upon bins of Marin water-colors, early, middle, and late, and plenty of the rarer—because Marin has only just started them—oils.

It's a veritable "corner". Mr. Stieglitz says that he is holding the material to pass it along to someone who will appreciate Marin—at a price! Whatever we may think of this rather hazardous way of doing business, it shows a superb confidence in Marin's greatness, and at any rate the bins of An American Place offer a priceless opportunity to study the work of the most interesting living American water-colorist.

The first thing one notes in Marin's work is a large way of looking at life. It is written in every brushstroke he makes. Man, in whom he is comparatively uninterested, except in his street scenes, figures not at all in his scheme of things. The purity of nature, away from rather than dominated by man, is Marin's study. This sturdy, isolated Yankee artist of almost three score, born in New Jersey but just as down-East as the Maine in which he habitually lives, has nevertheless the Chinese touch in envisioning as well as in painting landscapes. The Chinese, too, in their landscape paintings make man of little account. He is always

dominated by his surroundings, like the people in Marin's cities. As for Marin's water-color style, the washes he slaps on—for it is difficult to think of him working very deliberately—are Chinese in essence, delicate, subtly organized, and full of mystery.

Come into a room where a few Marin water-color papers hang. Assuming that you are cold to his work, you will probably not see from the threshold of the door very much of the subject the painter was trying to convey. But then as you come nearer or study the pictures more intently, you will probably find that what seemed jumbled mixtures are starting to coalesce and to reveal—just as in the Whistlers and the Brabazons—well-defined form and meaning where at first you thought there was none. The water-colors become, they are, pure poetry. Critics have compared them, in fact, to Shelley's, which was poetry, concerned, as Marin's, with mysterious concatenations of wind, storm, sunshine, acting and interacting on lakes, trees, ponds, mountains, and sea.

Marin has always had the poet in him. He found this out when he tried his hand at architecture, being more interested, as E. M. Benson says in his Marin monograph, in drawing "bunnies" than in drawing blueprints. He was twenty-eight, then, but this mild hookey influenced his family to send him for proper seasoning, in 1898, to the Pennsylvania Academy of Fine Arts. The oldest art school and museum in the country, it had already had to its credit such people as Thomas Eakins and was shortly to have Demuth, Sheeler, Henri, Sloan, and others. Marin did not let the usual copying of the great masters put him off his

bent, but—what is unusual in a student—at once began painting, by himself and in an original manner. Perhaps this was because he was older than the general run of students. He soon had a first prize in landscape to his credit and the encouragement of his conservative master, Thomas B. Anschutz.

He left the Academy's portals in 1900 and then, as far as his work was concerned, spent five years wastreling in New York. The next five years find him mostly abroad, in Paris, Venice, the Tyrol, Amsterdam, and London. Edward Steichen, the photographer, became acquainted with Marin's work through Arthur B. Carles, the flower painter, and Marin's former classmate at the Pennsylvania Academy. Steichen wrote to Stieglitz, another photographer, about Marin and this was the turning-point in the latter's career.

Up to that time he had been eking out a precarious existence by the sale of his own etchings for two dollars apiece. But now, in 1909, Stieglitz gave Marin's watercolors an exhibition in New York and then, in the summer, went over to Paris to meet him. He signed him up, so to speak, to "291"—Stieglitz's Photo-Secession Gallery. This and its successor, An American Place, have been Marin's stamping-grounds in New York. The agreement was that Stieglitz should give Marin a fixed income, which could be repaid out of future sales of the artist's work.

Marin could now go ahead and devote himself to painting rather than pot-boiler etchings. He returned to America in 1910, found New York unbelievably altered and inspiring to both pen and brush, left marvelous *brio* sketches of her canyons and skyscrapers, and then betook himself to

Maine to live. Of course he was back three years later to exhibit in the famous Armory Show.

With this great international exposition, sponsored by Marcel Duchamp, the painter, Walter Pach, painter-critic, John Quinn, collector, and Arthur B. Davies, painter and connoisseur who got the exhibitors from all over Europe and the United States, modern art burst like a flood upon a generally unsuspecting American public. It was the art Marin stood for, although he was never influenced by Cézanne—selective, impersonal, yet, to many people who had never seen it, apparently confused and therefore ugly. This has not, needless to say, been the verdict of the succeeding years. Marin is now looked upon as a painter of great delicacy of perception, whose glowing colors—ochrish reds, cool blues, and greens—have the beauty of furniture inlay and who bestows on his presentation of a scene a panoramic, catholic outlook that, far from being insipid, is dynamically wise.

But in 1913 and for shortly thereafter the stature to which Marin was to attain was unpredicted. His water-colors of that time seemed less well organized, more cluttered, more distorting. But today they have reached a fine technical norm. Marin paints mostly Maine scenes—islands, mountains, spits of land, lakes, the ocean. He is a true modernist in trying to suggest to you in one picture the essential nature of a schooner or of a tree or of a ferryboat or even, rarely, of Fifth Avenue, catching the subject in varying forms of movement which in nature follow each other, but which in Marin, in art, can be suggested in the same drawing. Yet, by making enframements, with broad paint, for the picture

as a whole or for various sections of it, Marin suggests the thought that it is a momentary glimpse of an object framed through the window pane of eternal vision. Thus, he welds the immediate and the sensuous with the ultimate and the impersonal—a thrillingly satisfying combination.

It is almost discouraging to have to add that to frame a Marin well would seem to cost a fortune. Despite the artist's own attempted anticipation of the framer's work by thick lines of paint, Marins look their best when framed. Yet because he himself envisages on the water-color paper his own mat—by leaving edges white and untouched, his aquarelles may not be matted. Mr. Stieglitz has therefore devised for Marin what he calls a shadow box, acting as a presentation of the water-color in question. This shadow box is a shallow box about two inches deep, the sides of course being the sides of the frame. The lining of the box is Japanese vellum with real silver leaf. When the Marin is placed on it, a gorgeous effect ensues. Or I have seen some of Marin's schooners and Maine islands framed in an enameled black with thick bands of gold beading, and again the effect is stunning.

This question of framing may seem precious, but outside of affording a good ground for recognizing a Marin, it brings out the austere, delicate, Chinese, and brave quality of his art. It casts a definite halo around this painting of subtle yet spontaneous abstractions, of muted, singing colors, of inspired and romantic feeling for stern reality. The sharp edges with which Marin defines forms consti-tute a reflection of this painter's feeling for the lightning shafts figuratively glancing about us. There is something

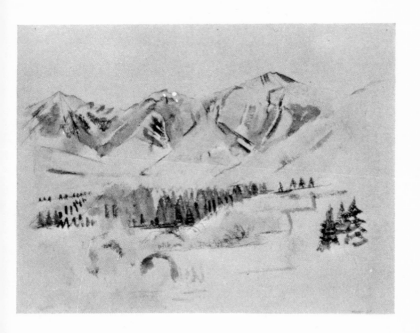

MARIN
Presidential Range

MARIN

Democritan about Marin. Atoms are clashing in the air, you feel, in his work. There is lots of felt movement, as there is in the work of "Pop" Hart. To this warring of the atoms Marin adds a structural sense, so that, as one critic has written of him, with a distinguished shorthand Marin shows us nature skeletonized. To those who believe that nature's corpse or anatomy is inartistic Marin everywhere gives the lie. Nature's structure is as complicated as a network of railway tracks in some large terminus but, like them, her lines and tentacles lead somewhere.

ANDRE DERAIN
(1880-

DERAIN

I N an age like the present when adherence to ugliness has made the names of not a few artists whose chief virtue was their vitality, it is refreshing for once in a way to come upon a painter who has arrived at greatness without the exploitation of any grossly sensational quality. To love Derain is to love unadventitious beauty that is modern in the best sense. It is to love simplicity, substance, and sanity. It is to love natural charm built upon measured steps.

Derain started out as a *fauve*. But, much more than was the case with Matisse, he was un-fauvish. Of the fauvist school, indeed, only Rouault maintained his uncouthness and the very heavy black contour line which distinguishes this technique. In Derain's fauvist studies, several of which, like "The Dance", were in the John Quinn Collection, he seems a weak echo of Matisse. His rhythm, rather than his design, seems important—a state of things which he was soon to reverse, design being to him the more natural, as he had trained for the engineering profession before turning painter.

There is nothing sensational in Derain's life or career. We cannot say that his work is exciting any more than we can say that refinement is exciting—save (and it is a very large exception) for its civilization. He made the acquaintance of Matisse in 1898 and the two were painting together at Collioure in 1905. A few months afterwards they were

exhibiting in the Salon d'Automne and finding themselves called the Wild Men or *Les Fauves* because their then incomprehensible or advanced pictures happened to be near a sculpture by Donatello!

Although Derain has the Frenchman's innate sense of decoration possessed by Matisse, he is more interested in depth—and hence in Cézanne.

John Quinn owned another Derain, "Le Joueur de Cornemuse", an early landscape of massive proportions, in which the painter had obtained his sense of depth in a way not much inferior to that of Cézanne. He had contrasted his light with his dark planes, but, if memory serves (I saw the picture at the Quinn sale), there was almost no red in it. Instead it was made up of aquamarine, gray blue, dark greens, and browns. How, then, was the recession of planes to produce distance so successfully created? Answer: by interposing, as it were, wings, such as those on a stage. The eye was thus led back by varying estoppages of the view.

This method is more evident, I think, in "The Old Bridge" of the Chester Dale Collection, painted about 1910. Its composition is similar to that of a painting in the Impressionists' style by the late Robert Spencer, called "An Old City". Yet "The Old Bridge", austere, abstract, and simplified, has a much better sense of space. In it a lot of red is used both in the foreground and in the roofs of buildings, yet its depth follows from the manner in which the right and the left sides of the canvas crank in the central register, as if in a vice. Minor stage-wings are created by the pine trees, while the foreground bridge is a very

useful stage property for fostering the illusion of depth. One is not surprised that this work, which followed hard upon Derain's fauvist period, was painted under the influence of Cézanne. It proved that Derain had finally come to himself as a designer.

Suddenly he seems to change his landscape technique, and we discover him going in for woodland glades, where he emphasizes the rugged boles of forest trees in the manner of Marchand. "The Three Trees" of the Lewisohn Collection, dating from about 1922, responded to this still austere and classical design but looser handling, and is a good example of the works of this period. The canvases seem to be painted *de tout près*. Their carrying power, owing to the broad brushing and strength of the design, is greater, but they do not represent such stretches of distance as his latest, and most surprising, landscapes.

These gems of landscape art serene have been achieved within the last decade. They may be effectively illustrated by the enchanting "Southern France" of 1928 in the Phillips Memorial Gallery and by the series of wooded and hilly slopes (whose chief fault was a garishness of sky) which were dated 1930 and were exhibited at the Marie Harriman Gallery, New York, the succeeding year.

In this later style Derain has become much less studied. His paint has almost a liquid gloss to it, is put on thickly without showing the canvas, and is no longer applied in very flat color. "The Southern France" has a quiet, sabbatical charm, whose grace recalls Vernet and Louis-Gabriel Moreau and whose restful horizontality, Georges Michel. The lighting is Reinhardesque, done by a curiously circular

77

cloud effect which yet possesses the eerie illumination of the sky at dusk with filaments of cirrus upon it. The horizontal lines of the landscape proper and the resultant peace and harmony are worthy of Bellotto.

Derain has chosen subdued colors for his new and rather delightfully impersonal landscapes—greens, chocolate and orange browns, and sandy ochres, with shades of black and blue for stormy or leaden skies. This palette, which may be observed, except for an aquamarine sky, in the "Route d'Orgon" of 1932 at Durand-Ruel's, is eminently suitable for the modern landscapist, who is confronted with the fashion of doing artistic landscapes directly from nature. In such landscapes, or in the notes for such landscapes, spontaneousness counts.

Derain, by an elimination of fine detail that neither Poussin nor Claude in their wash drawings apparently could equal, has hammered out a landscape style which is fabulously grand. Penetration of distance has been a quality to conjure with in the history of landscape art. Very few artists have had it, for in actuality it made its appearance late in the annals of Western painting. Giorgione and Patinir had it, and so did Claude. But only in the greatest painters, Turner, some Dutchmen, Constable, Crome, Bonington, Corot, and Pissarro, and after them Cézanne and Marquet, has the quality been developed farther. Derain is the culmination of it.

Cézanne, as we know, reached into the distance by means of his contrasting planes of color. Gauguin, as we know, didn't, or couldn't, get into the distance because his areas of one color were too broad. Yet Derain succeeds in reach-

78

ing that destination at least as well as Cézanne—through a combination of the two systems. These later landscapes of his, one feels, are governed by one or two, at most three, great ribbons or waves of color upon which are superimposed, as not in the Cézannesque works, shreds of gently related tones.

This style has given Derain's landscapes a smoothness which is only enhanced by the luminous quality his paint takes. Although they are perhaps really more impressionistic than classical, their spirit is one of classical idyllism—repose, nobility, unvariable harmony of the earth, and universality. It is difficult to praise them too highly. They are, as has been well written, triumphs of elision. But they are almost Theocritan in their refinement.

When one comes to Derain's portraiture, there is no hesitancy in terming it Grecian. His first portraits, to be sure, of which John Quinn had some, had woebegone faces of the kind which the Cubists used to draw. They had Punchinello noses and split-plane faces. But at that time Derain had not found himself.

In the 1920's he emerges in his true colors. He chooses pleasing sitters, poses them interestingly, although not always solidly (e.g., "La Jeune Fille à la Chaise" of 1932), and draws them beautifully. It has been said that Derain, to whom color is secondary, draws with his brush. Hence, the power he has of varying his characterizations.

No other portraitist of the modern school draws fingers, hands, and arms with such grace. We will not find him addicted to the enamel-like passivity of Kisling or to the distortioned daubs of Surrealists like Ernst. One can stand

and honestly admire his work. Its moderation of tone and pigment may not make us catch our breath, but it will rivet our attention through its natural winsomeness. While his thoroughly modernistic portraiture, exquisite in its flowery grace, is sometimes flatly modeled in the Manet manner for the face, as we see in the "Fillette au chapeau de paille" of 1929-1930 at Durand-Ruel, an earlier style of 1928 modeled sitters much more in the round, à la Zuloaga. Derain has also certain methods for depicting character, as for example, the flat siena of the sitter's face in "The Guitar Player" of the Stephen Clark Collection, which, like a red ball, focusses the eye on it.

As a master of still-life, Derain might have to take a place behind one or two other modern painters. Demuth, Van Gogh, Verburgh, and Vlaminck have done some astonishing things. But Derain would not be very far in the lurch. There is a still-life of pears, oranges, and grapes (now in the hands of Durand-Ruel) every individual fruit of which, posed against a reddish molasses background, seems to emanate from the gesso-like thickness of paint. Or again, in the "Still Life with a Bottle" of 1932, there is the roundness of a pale green melon vitalizing the right, a black bottle with a white napkin stuck therein just left of center, against a dark background, with the horizontal note of a long loaf of bread and the silvery sheen of a table-knife blade in the foreground. From such simplicity is developed an art, perhaps not unlike that of Chardin, but more sensitive to modern feeling.

This is the man, then, whom critics have called the typical modern French painter. He has intelligence, distinction,

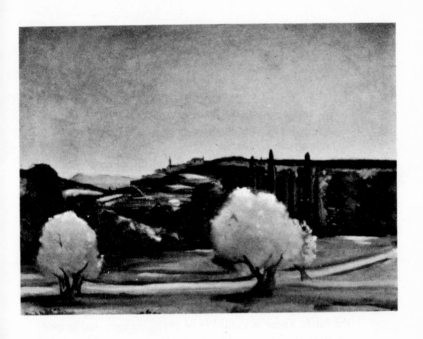

DERAIN
Southern France

and spontaneous charm. He is not interested in the facile or the pyrotechnical. He can be modern without gawkiness, lovely without sentimentality, or sombre without gloom.

CHARLES DEMUTH
(1883-1935)

DEMUTH

NE of those refined beings who belong to the world of Hawthorne came to fruition in Charles Demuth. The gods gave him imagination, style, and a unique manner of saying things in water-color. Hawthorne is not a little like that. The imagination of the solitary which saw the things that hover between the dream world and the mundanities, the crystal-clear prose, and the aquarelle-like delicacy of his sketches and tones, are matched by this modern American painter who divided his time, as did Hawthorne between Salem and Concord, between Lancaster (Pennsylvania) and Provincetown.

When Demuth died in October 1935, aged fifty-one, there was a strange apathy in his obituaries. The art world did not seem overcome and many people, vaguely putting him down as a painter who specialized in American scenes, let it go at that. But does any painter sponsored by Alfred Stieglitz specialize in American scenes?

The knowing knew where to place Demuth. His refinement, waiving his early water-colors of burlesques, was neither of this time nor that. For his paintings, most of them so abstractly dignified and universal as to earn for him the name of "Immaculate", had only the slightest interest in the moil of American life. Several newspaper reporters missed their signals in their obituaries of Demuth and confused him with Grant Wood or Stephen Etnier.

Yet Demuth betrays no personal-interest motif in any of his mature work.

What he does betray is an interest in architecture, an interest so loving as to set him as one apart, even from Sheeler. He took the spires and cupolas of old colonial churches, focussed on their lovely Wren-like details, and then threw prisms of light around them, as Marcel Duchamp did around his "Nude Descending the Staircase". They say that Demuth was much influenced by Duchamp, but where the cubism of the Frenchman was cluttering and distorting, the echoes of it in Charles Demuth were actually clarifying. The literal American mind, however, has to have its bottles labeled and could not accept Demuth's "My Egypt"—which now graces the Whitney Museum—as authentic (though it is as surely a Nile boat as anything else) but must go and call it, merely because a boat has a funnel and certain architecturally straight lines, a factory building!

But Demuth didn't mind. Sick in body as he was for most of his life, he went ahead, as some people asserted, "specializing in American scenes". That is to say, he painted flowers, vegetables, and fruit, which included gladioli, tulips, daffodils, lilies, and cyclamen, and pears, bananas, egg plants, tomatoes, and watermelons, as no one else ever has! They were water-colors, these beloved subjects of his, and generally large ones. He used the central part of the paper for his design and left edges, often for a good distance inward, bare. In that he is like Marin, but where Marin paints with the explosive brio touch, Demuth is the architect careful to include everything well within the ropes

of his ellipse, perpendicular, diamond, or whatever imaginary bond he has chosen to keep his design well-knit. But the white paper of the block shows not alone on the edges; it shines through the watery pigments themselves or shows when the pigment designedly ceases.

From whom did he learn this? It may have been from Cézanne or Marin or even Maurice Prendergast. That is why, although Demuth's fruits and flowers are as coolly immaculate as wax and as studied as immortelles, they are vitalized by a translucent glow, the type one gets from, say, quartzite. From Cézanne he may have learned his method of building up the tone on the surfaces of fruit, but he was not a Cézannesque, for his things are finished and elegant, they have more *hauteur* than Cézanne's, and in the design there is more rhythm.

Here is an artist, then, who has done a difficult thing superlatively well, greatly. There is nothing so bromidic as the after-dinner speech, the National Academy, sculptures of Justice, and still life. All of them are characterized by the hackneyed. To metamorphosize the bromidic into the great is always an arduous and thankless job. But it is worthy of great souls, and what others can do in revolutionizing speeches, the National Academy of Design, and allegories of Justice, the true painter, the Van Gogh, the Cézanne, the Demuth, can do in revolutionizing still-life.

Demuth was born and lived in Lancaster, Pa. His masters were that inspiring teacher and less inspiring painter, William Merritt Chase, and Anschutz, both at the Pennsylvania Academy of Fine Arts. But like Marin before him, Demuth did not respond to the ordinary instruction in genre or still-

life. He had his own bent to follow, so that to be happy he did not have to take large slices of American life, like Glackens, Sloan, and Luks, who were the typically successful products of the Pennsylvania Academy.

He went abroad twice and painted in Paris from 1911 to 1913 but the change seems to have affected him very little. Demuth, in fact, had the same style, the same technique, in his later years that he had when he first began to paint. But this is not to say he is a dullard of a single-track mind; rather that he sprang full-blown from the head of the Muse. There are always great artists, like Demuth and Max Beerbohm in literature, whose first appearances are as polished as their last.

It is fitting that one of the American contributions to our list of painters should be chiefly a water-colorist. Marin of course is another worker in this medium. Modern American water-colors hold a place apart and are perhaps a stage above any other modern water-color work, excepting possibly the very gifted but conventional work of certain Britishers like Muirhead Bone, James McBey, and Wilson Steer. Santayana once said that the American mind, being shy and feminine, liked to paint nature in water-colors. This is particularly true of Demuth. His ventures into tempera, oil, and etchings have been few, generally confined to buildings, or factories (which are suited for oil), and it is usually as a water-colorist that one thinks of him.

Outside of having made a very intriguing adaptation of Cubism for his architectural paintings and some of his still-lifes, Demuth reveals no other tangible influences upon his style. He had an impish humor, of the sort that went in for

strange titles. He would call a tempera painting of some factory chimneys "The Piano Mover's Holiday", another of a ventilator and some chimneys "The End of the Parade", and the side of a grim building strung with telephone wires, "From the Garden of the Chateau."

He was an original artist. The one time that he seemed derivative was when he tried to paint like Sheeler. (Or it may be that Sheeler was trying to paint like Demuth!) Sheeler was an exact contemporary and also studied at the Philadelphia Academy. The particular picture I think of is Demuth's "Stairs", his water-color just acquired by the Museum of Modern Art. This work is just like Sheeler's "American Interior", except that the stairs are mostly on the right instead of on the left. But, like the Sheeler, it can be inverted with little aesthetic loss. It was probably done as an exercise, yet shows how close the points of view of these two painters appear.

Henry McBride has told me that every Fourth of July the Demuths would give a party for all their friends. You went into the house to find yourself in a denful of beautiful antiques. Should you get up from your chair and happen to look at its seat, you would probably be surprised to find that you had been sitting on both some fine needlework and a fine Demuth. The facts would then come out that Charles had made the floral designs—and very lovely they were—for his mother's needle.

Cubistic designs are suitable for furniture coverings in the modern house. But there haven't been, in America, many cubistic still-lifes. Demuth, in his water-colors, as in his chair designs, is one artist who has not been afraid to

build up a substructure for his fruits and flowers that is cubistic. He then paints each zone so divided by the substructure in its true colors. Such a course gives to the flowers their pearliness and to the fruit its quartz-like tone and prismatic appearance. These water-colors are always sparkling, with a tenderness very French in its impeccable harmony of somewhat neutralized colors in high light.

Few water-colorists would care to take such chances with over-lapping washes as Demuth. Often in his fruit studies, like the "Peaches" of the Gallery of Living Art, one wash runs into or is covered by another in a way to make the purist throw up his hands. Yet the resulting tone seems to be perfect for the picture and in some cases a lovely darkness has been obtained. Bertram Hartmann, as well as Marin, has latterly developed this style, which is to be seen in all its glory in Demuth's vaudeville sketches and illustrations for books. The water-colors of dancers, where the play of shifting lights and the sense of motion is necessary, show this very well, as the "In Vaudeville" of the Gallery of Living Art.

People will say that Demuth was too refined. If so, he had the refinement of the philosopher who by knowing all forgives and understands all. There was no need for him to do over a Benton, a Curry, a Marsh on nature. Indeed, the times that he tried, in the early water-colors of his pre-1920 days, he was not a howling success. Nor do I care overmuch for his book-illustrations where he has given his interpretations of the plots of Henry James, Zola, Balzac, Poe, and Wedekind. They have good conception, but the painting and the line are not world-shattering. The forms

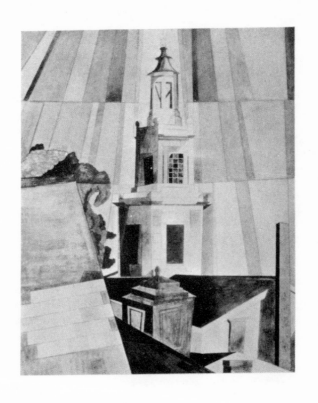

DEMUTH
After Christopher Wren

are jellied and the color sometimes mottles up like snake-skin.

I have seen only one landscape by Demuth in my life. Yet it was superb, a picture (now in the Kraushaar Gallery Collection, New York) of the rolling sand-dunes near Provincetown. It was extremely abstract and simplified, a wave-like design with mere washes of two different shades of brown for the sand, one of yellow-olive for dune grass, and one of gull-gray for the sky, but these so flaky and pearly that one thought they might dissolve if breathed upon.

As a subtle recorder of architecture, of the cubes and polygons and triangles he could find in nature's forms—in houses or sailboats or flower petals—the man had obviously few equals and no superiors. He knew how to build up color and knew how to build up form. You will see, if you will look at his architectural things of ten years back, that here are among the first records of the stark, artistic value of modern concrete and ironwork and that in Demuth's houses, industrial chimneys, and steamship funnels, we have a pioneer work long before Peter Blume, Elsie Driggs, and Virginia Berresford had started to work out very similar designs.

Nor do you have to look long at Demuth's still-life to know that therein he was a master. It is decorative and subtly realized, in the same way perhaps that a magnified flower by Georgia O'Keeffe is subtly realized. We feel we know all about this fruit or this flower. As original artistic conceptions, they are as light as thistledown. A humming-bird's gleaming wings seem hardly more iridescent or dazz-

ling. And as we look and look at them (which, by the way, is Demuth's own touchstone for great paintings) we come almost to have a new point of vision. We seem scarcely ourselves, but to be living in a sort of insect world. And in this world we see just the things a fly would.

The exciting thing, then, about Demuth is that due to his subtlety and tact, endless new things can be discovered in his still lifes. They are as voluminous in fact and meaning as the art of Proust. They are as compact of associations, memories, and "inner life". Proust made the soaked madeleine conjure up a whole past world of sights and smells; Demuth makes the daffodil, for instance, do the same and his poetry about this flower is much more delicate than Wordsworth's. Yet it is the delicate poetry of modern life, for modern life—so says Demuth everywhere in his work —has its delicacy, though Benton, Curry, and Marsh believe it not. It is the pervasive delicacy of subtle thought, and as it is grown on by no means every bush in America let us cherish it duly. A true "Immaculate" in precision, refinement of line, and selective ability, Demuth had the inner feeling, a splendid detachment, that fused his art into an emotionally moving whole and kept it from being—what the art of some of the other "Immaculates" has become— soul-less. If Van Gogh might be classified as the painter of robust sunflowers, we might not be unjust in calling Charles Demuth a master in immortelles.

GEORGIA O'KEEFFE
(1887-

O'KEEFFE

WISH people were all trees and I think I could enjoy them then." Georgia O'Keeffe actually said this. The sentiment is just the opposite of Thomas Hardy's

> "Since, then, no grace I find
> Taught me of trees,
> Turn I back to my kind,
> Worthy as these.
> There at least smiles abound,
> There discourse trills around,
> There, now and then, are found
> Life-loyalties."

But in the plant and tree kingdom, among the bare mountains of the world, Georgia O'Keeffe has found *her* life-loyalty.

In some far distant day, when our age has become a geological entity, if any O'Keeffe paintings should happen to be preserved in a museum of that future, they will seem like the marks of an ancient leaf found in a stratum of ore. There is a timeless, but no soul-less, quality about them. The people of that age will say to themselves: flowers then were much the same, but see how this artist has hallowed them by taking us right into their hearts—their stamens and pistils—and shown us the divine beauty in which they were

shaped. Look, here she is again, painting for us the likeness of a steer's fleshless skull, between whose horns she sets the freshest of white roses. The timeless beauty of the vegetable kingdom wins out over the mortally longer-lived but grosser animal realm. The world of the flower, the plant, and the leaf, so fragile, so temporary, is nevertheless the consoling and deathless world of beauty—when, that is, a Georgia O'Keeffe can create its pattern.

If I were asked who was the least derivative of American painters, I should say without a moment's hesitation O'Keeffe. She has never been abroad. She has studied at the Art Institute of Chicago, at the Art Students' League in New York, and knows the ways of schools, having herself been both a supervisor of public schools in Texas and a college teacher. Yet the singular simplicity of her art has remained through all this schooling. She has never retreated one inch before the demands of different taste or opinion, but has been herself. That self is true to a nature of highly controlled intensity, bespeaking plangent and original emotions.

O'Keeffe sees everything in the large. If it is a leaf, it is enlarged until, on the canvas, it is three or four feet high. But such height, the attainment of which might make a leaf as painted by another painter repellent, makes an O'Keeffe leaf outstanding, for we know we can associate, with such a canvas, burning, radiant colors. Thus, an autumn maple leaf will be shot through with a gash of most stimulating orange, as if its heart were radiant with fire. You never saw an autumn leaf quite like an O'Keeffe version. But her version puts the poetry of gallant, flaming life, the gust of

the wild west wind, into the subject.

When O'Keeffe turns from leaves to flowers, the flower is shown on an equally magnified scale. At all points it seems to be open for observation, turned back like a butterfly's wings pinned to a museum card. Butterflies, by the way, as well as all sorts of insects, I can imagine having great fun crawling about in O'Keeffe's flowers. Or rather, while we have an O'Keeffe flower-piece in front of us, it is almost as if we humans were the butterflies. It is on this scale, we may be sure, that flowers appear to the real butterflies, moths, and caterpillars. Somehow or other this is a chastening thought and we return to other concerns, after admiring the gauzy, pastel colors of a typical O'Keeffe flower—pansy, primrose, or petunia—with a feeling of humility for having trespassed on a mysterious world of great beauty and intensity.

Much the same sort of feeling is evoked by Georgia O'Keeffe's other work. Her paintings, large-scaled and chromatically glowing as they are, have a soothing effect. Framed in a snappy chromium border whose top edge is barely flush with the glass and which has been designed by herself, such a painting is memorable. Or perhaps it may be framed in what has become known as the O'Keeffe frame, because she originated it: a soft-wood frame, with six mouldings of varying curvature, sized and silvered, and turned out (as are her chromium frames) by a special Russian framer. But to return to the paintings.

She plays with surfaces rather than with lines, making this abundantly clear in her studies of architecture. She has been to Taos, New Mexico, and has painted there about

1930 the stuccoed exteriors of churches and houses and the great bare cement walls that surround gardens. She has crinkled her usually impeccable line with the result of roughened edges in the architecture. The buildings look as if they had been blocked out with a mason's trowel.

This is the one exception in Georgia O'Keeffe's painting to a careful, meticulous technique. Yet the amazing thing is that even when her technique is invariably smooth, she has so many powerfully persuasive things to say. Her master, William M. Chase, under whom she won her first prize (a first in still-life), had a broad style in painting, quickly and boldly laying on the paint in the Munich manner— from a heavily-loaded brush. His was an art of rendering surface textures in still-life, but he was not successful in rearing O'Keeffe in those traces. She wanted to pierce the heart of things and although she does so in her Jack-in-the-pulpits, calla lilies, and rugged red New Mexican hills and arroyos, what she finds there is still mystery. In this she is like Burchfield, whose early water-colors of flowers done before 1917 are evocations of mystery, though Burchfield is obliged to distort his flowers and houses into gollywogs and ghouls in order to be properly ghostly. O'Keeffe merely magnifies, and at once mystery, in a smooth, faultless, immaculate palette of pure, wooing colors, is created.

Thirty years ago, almost, O'Keeffe was in Chicago drawing for the ads. Twenty years ago, at the age of thirty, she was unknown. But in 1917, while teaching at one of the State Normal Colleges in Texas, she happened to send some drawings in lieu of a letter to a friend in New York. This friend turned out to be a friend indeed, showing the

O'KEEFFE

drawings to Alfred Stieglitz.

It would not be amiss to digress for a moment on Alfred Stieglitz. In the first place, he is O'Keeffe's husband, her drawings being, as it were, the marriage knot. Secondly, he has done as much, if not more, for modern painting in this country as the next man. With Gertrude and Leo Stein, with Marcel Duchamp and Walter Pach, he helped, as we have seen, to set the stage for the entrance of modern painting in the Armory Show. At his galleries, first, "291" or Photo-Secession, and, then, An American Place, he first introduced to the public the work of not only Marin, Demuth, and O'Keeffe, but also Arthur Dove and Marsden Hartley.

Marsden Hartley it was who wrote of O'Keeffe: "She has wished too large and finds the world altogether too small in comparison". Such an excellent epitome might be used to characterize figuratively the reception of her drawings in 1917 and its aftermath. In 1920 she found herself being given a large exhibition at the Anderson Galleries in New York and four years later married to Mr. Stieglitz. In these last twelve years she has become a figure in American painting with an enviable reputation. Her periodic residence in New York has made it feasible for her to paint the city's skyscrapers and rivers seen therefrom. Her rendition of the Radiator Building by night is splendidly unforgettable. The myriad windows glowing with bright light take on, in O'Keeffe's painting, the quality of jewels set against dark blue velvet—the blackish blue outlines of the building. She has done several studies of the East River seen from tall buildings and here her palette is full of dove-

99

greys and grey blues, reflecting the grisaille through which
the panorama of the metropolis often unrolls. This is highly
successful work, but is more mathematical, less intense as
to color and feeling than her flower-pieces.

A word as to the wrong manner of appraising these
flower-pieces of Georgia O'Keeffe. Not a few critics have
attempted to read into them more than she meant to convey
and have thus confused the public. These men have written
pompously to the effect that O'Keeffe's flowers had human
emotions or were the symbols for human emotions, espe-
cially of sex. Such criticism gilds the lily more than
O'Keeffe ever does. She takes us of course into large, mag-
nified flowers, but what we see there by implication is noth-
ing more than we see in the flower when not under the
microscope. To read more into it is to become a victim of
very wishful thinking. But one may say this while stating
that her flowers do suggest a world—a delightful world—
of their own. It is Burchfield rather than O'Keeffe who
gives flowers *emotions*.

The flower-pieces—and even the white house O'Keeffe
calls a Canadian barn, with its almost liquid roof—shine
with a white radiance, which is so strong that it is hot. In-
deed the glare in her work has been prompted, as O'Keeffe
herself admits, by her aspiration to achieve the color red
in the paint called white! She can already almost achieve
the converse—white in the paint called red. These curious
effects, as by a magician wending his way through color-
chords in the Clavilux, emphasize the great, un-niggling
spirit of O'Keeffe's paintings. When a painter so plays with
color that the observer begins to forget the name under

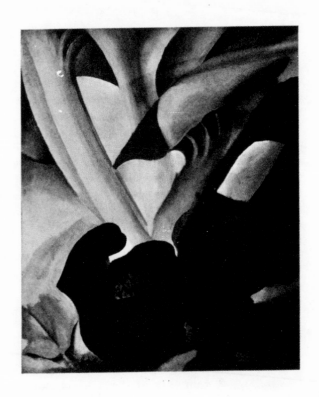

O'KEEFE
Skunk Cabbage

which it usually goes, then that painter is living in a dream world and leading you in, too. Both of you are starting to talk the same language and the not infrequent result is that you both become voluble. The disdain that you might once have had for dreams falls off and you are living with another soul as naked as yours, each parched with a thirst for a spiritual interpretation of the universe. That O'Keeffe's strong, forthright, and spiritual paintings offer such an interpretation in a style at once original and convincing is sure sign that she is on the right track to—greatness.

JEAN CHARLOT
(1898-

CHARLOT

T a time when most painters are concerned only with form and forget direction, or with direction and forget form, or with color and forget both form and direction, Jean Charlot can emphasize each in every canvas he paints. One of the most studious and versatile painters of today, powerful, and undeniably one of the most persuasive, at an age still under forty, he has mastered fresco, canalized the art of mural painting in Mexico—though he is no Mexican—and although the compositions of his works are as if they had been solved by the pure cold music of mathematics, he has produced pictures pulsating with warm, stirring human feeling. Charlot, if his approach to painting is intellectual on the professional side—like the approach of a twentieth century Delacroix—always limits his scientific pyrotechnics to re-enforcing what he has to say. There are times, when in Charlot's working out of an especial problem, such as how to underline the spatial qualities of a landscape, the spectator is so sincerely astonished at the technique that he must gasp a moment at it before reacting to the subject matter itself.

There are many painters today whose technical abilities are great. Some of those members of what Mr. Duncan Phillips has dubbed "The Immaculates" are technicians, their products being as airless as they are spotless. Men like this, Niles Spencer and Stefan Hirsch, for example, achieve

comparatively soul-less paintings. That is the difference be-
tween them and Jean Charlot. The work of Charlot has a
soul. He is a man obviously to whom ideas, as well as the
manner of expressing those ideas, mean much. Simple, un-
confounded, is his wise vision of humanity. His pictures
reflect it in all moods—at work, such as the building of
pyramids; in the family, such as the spaciousness of mother
love; at war and in agony; and at devotion.

For a man of thirty-eight Charlot has had a singularly
well-rounded life, equipped with the distinction of a schol-
larly background. Born in Paris, of a Franco-Russian father
and a half Spanish mother, he led there the life of the usual
French student. He was twenty and a lieutenant in the
artillery when the Great War ended. When as a member
of the French Army of Occupation, he found himself in
German territory he took advantage of this to go and study
the paintings of Grünewald, of the fifteenth century
Cologne School. Three years after the end of the War he
was in Mexico, living with his uncle, for members of the
family had been settled there for a century. He has not seen
France since.

Charlot had always, from the age of three, drawn—and
always, from a little later, written, so that, arrived in
Mexico, he was not long in demonstrating his talents in
both arts. From a long critical examination of Mexican
picture manuscripts he revived the woodcut and he illus-
trated poems. He painted the first fresco, which is in the
Preparatory School. As a writer he was able to look back to
the day when in France he had done his bit composing
classic quatrains and now wrote a Mexican letter on art for

Parisian periodicals. In 1926 the magazine "Mexican Folk-ways" was founded with him as art editor.

After completing "The Fight at the Great Temple"—the result is Uccello modernized—for the Preparatory School in Mexico City, he began that instruction (with Rivera, Siqueiros, and de la Cueva) at the Secretariat which created almost over-night a great school of muralists, the Mexican. Charlot trained masons, as he continues to train students at the Florence Cane School in Radio City, for "the preparation of walls for true fresco". As Paul Claudel says of him, he is born for fresco painting. His forms are large and monolithic; they "carry" superbly, but they "carry", not alone because they are broad forms, but because they have been well-designed and placed on a properly prepared surface.

In 1926 the Carnegie Institute sent an archaeological staff to Chichen-Itza in Yucatan. Charlot, due to his great knowledge of ancient Mexican civilization and his powers of draughtsmanship, was on it. His job was to copy Mayan frescos and bas-reliefs, and to root up stelae. Possibly he had a particularly strong scent for the latter from having been given, on the occasion of his first communion in the Catholic Church, some American grave-pottery. At any rate, he soon found a very valuable Mayan gravestone. No tropical sun with its scorching heat was too severe to send him away from his labors of sketching.

These years in Mexico, from 1921 to 1928, were the formative years for Charlot's style. What he had found to his liking was the unheralded, unassuming, offstage, and un-Spanish life of the Mexican Indians wrapped up in their

107

sarapes and as dignified as Roman senators tucked into togas. He found also that there was the splendor of intellectual order in this civilization, especially in the Mayan version of it that he found at Chichen-Itza. That appealed to him, for Charlot, if his forms are characteristically Mexican, is very French in his love of order and clarity. He is French, too, in the manner of twelfth and thirteenth century France: his ideas come from Catholic cosmogony, which was then intellectualized to its highest degree by scholasticism. He is austere without puritanism; intellectual without joylessness.

As La Farge found the Tahitians Hellenistic, so Charlot found the Mexican Indians like ancient Athenians. He observed that the Indian foot is always very horizontal and clinging to the earth, like the feet of the virgins of the Parthenon, and he so paints it. There is music in the noiseless glide of the Indian through the early morning streets; there is grace in the folds and cant of his *sarape*, pulverous as it is in color.

In so far as Mexico is concerned, Charlot's paintings are not sociological nor socialistic. Diego Rivera has attempted to inject such notes into his own work, and, besides making his art controversial, has not improved its aesthetic appeal. But Charlot, for one thing because he realizes that the Mexican problem is extraordinarily complex, has for the most part left sociology severely alone. In addition to being good art this is good sociology. For when sociology is simplest, when it can be reduced to everyday, easily-understood morals, it is at its best. Thus, one could be the most stony-fisted Midas and still love the congenitally poor *mestizos*

of Charlot's art, because, not only do they speak for humanity but because they do so with such a sweet, unangry note. Charlot has seen that these half-castes or full-blooded Indians are the remnants, the maintainers, of a beautiful and harmonious civilization. He has found their forms, broad, unangular, corpulent, the basic material for his art. As we think of the brown men of Mexico today, we, or at least I, think of them in terms of Charlot's block-like forms.

In contradistinction to the Mexican Indian's ample forms, well-cloaked as they often are in *sarapes* for the men and *rebozos* for the women, Charlot finds the forms of the average white model replete with angularity, sometimes graceful, sometimes gawky. Working as he now does in the United States, he is changing the character of his forms to suit his new knowledge. Of course he can draw upon his store of Mexican forms at will; set him a scene of Mexican life and out come the memories of intimate Mexican family life he has piled up in his scholarly and retentive brain.

But he is getting interested in the forms of non-Indian people also. Some of his crayon drawings of heads and torsos show this extremely well. The bony structures of features, the lozenge-like patterns made by crossed limbs, are emphasized by his pencil and brush, until we have results as full of bosses and patterns as a rocky hillside is of boulders. To keep essential direction or cast of countenance under the application of such guiding principles — and Charlot does it—is an achievement. There is nothing soft in any of his faces. Even those of the Mexican Indians in his family groups are as much characterized by planes and prisms. It is a modernistic manner, but, when employed

by a Charlot, it adds great strength to the portraiture. The same may be said of his illustrations for Hilaire Belloc's "Reformation Portraits."

Charlot, I am sorry to say, has done very few landscapes. My regret is due to the fact that the one landscape I have seen—he calls it "The Storm"—is so good that my mouth has ever since been watering for another. Very sensibly he adopts the Chinese philosophy in landscape. The Chinese believe that space, which is the most important thing to suggest therein, a space that shall shrivel up man into insignificance, is best suggested by direction and not volume. The early and late nineteenth century English landscapists from Crome to Sisley got their spatial effects more from volume and child's-play perspective than from direction. Their chief directive quality came in their handling of clouds. But with a Charlot landscape, like his one in the Glusker, or that in the Iselin Collection, New York, every form of tree, mountain, road, or field-furrow is directive, leading the eye back, around, across, up, or forward. Here direction as well as high-light creates atmosphere. Again is Charlot's ideal realized: to see an ancient beauty, here that of landscape, reborn.

Rhythmical, rightly repetitive, and geometrical, then, are great attributes of Charlot's painting, no matter whether he is landscapist, portraitist, or commentating muralist. But one could never conclude an estimate of this serious painter who seems always to be thinking in terms, if not of the past, then of culture, without mentioning two other characteristics of his work. One is the really amazing variety of his palettes—he never plays, like some painters, in one key ad

infinitum, or at least ad nauseam—and the other is the strong, distinguished character, the range of facial expression he can summon particularly in the region of the mouth, the brow, and the eyes. It is a character very close to human feeling. A person sleeping soundly has a deep disinterest and unconcern about this world. The face of the sleepwalker or of the snorer—that is a face that Charlot has mastered! Again, the distrust, or the pig-headed skepticism of ignorance or fear he can depict masterfully. He has known the exploited "little people" of this earth, the Mexican Indians, who have such emotions, and they have made wonderful "copy" for him.

But the variety of his palettes I find extraordinary. Time was when a painter needed to have only one manner, and one palette, to grow popular. I say this and one instantly, without doubt, thinks of Corot, with his fluffy, filmy blue-green groves. Yet many other painters of the past, and even some of the present, are distinguished by one style. It is like one metal and one locality that has been so frequently ored that the mine is in danger of running thin. This sort of thing, however, doesn't go so well today. Today the successful painter, if only to show his intellectual alacrity and artistic sensitiveness, usually goes through a very gauntlet of styles. People feel that this adds to his stature, as they say it does to Picasso's, although I disagree with that, as I believe Picasso is a sadly overrated painter who has been intent, part of the time, on ramming jokes down the throats of the public. But he has gotten away with it, for he is nothing if not clever. Where a variety of style readily adds to stature may best be seen, I think, in the case of Charlot.

I believe painters change their styles quite sincerely. They wish to find a medium or palette more stimulating to them. It follows that if you feel that one palette brings out what you have to say better than another, you work in that. It also happens that you had nothing to say in one palette, and find a great deal in another. Or you are simply bored, and want to try something new and original. This idea, rather than that of shocking people, lies behind many of the *volte-faces* made by painters. Then again, there is the idea, essentially the most profitable of all, that only in constant change is there in art any progress. It is a good religious hint which says that "as long as the understanding finds no trouble or difficulty, and is at ease, that is a sign that one's faith has not gone far enough." This may be paraphrased for the world of a painter's conceptions.

Well, Jean Charlot, as a mark of his progressive nature, enjoys changing his styles. I have referred to the natural change in his forms that came over him with the change from Mexico to the United States, the change from broad forms for people to angular, svelte forms. I have seen drawings of his so free that you might have thought Max Ernst had evoked them; and I have seen drawings of his—the ones for Belloc's book—so "tight" that Ingres, if he had had a sense of humor, would have been marked as their author. But even these drawings, disciplined to mere facial cameos by publisher's requirements, had as much strong differentiation as though each had been by a different artist.

But I promised to speak of Charlot's different palettes. It is in color that his range is especially wide. Note the way

112

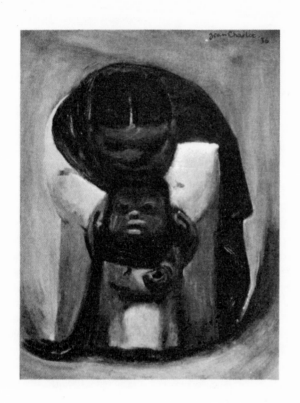

CHARLOT
The First Steps

in which after painting his picture in the conventional palette, he can add another color in very small amount, which acts *sostenuto,* like the middle pedal of the piano. Thus, in one of his landscapes, of a storm or of "The Agony in the Garden", he composed the scene in turquoise and a light, neutralized blue containing a tinge of purple. Suddenly, wrapped in the whirlwind, as a sort of mandorla, appears the angel, rendered only with one wing and the head, but these in a loud, intense purple. The use of this color might almost scream, but Charlot makes it sing. In another composition, "The Nailing to the Cross", the painter has been able to introduce ultramarine into what would ordinarily be the closed corporation of pinks, greens, and straws. In the "Annunciation", lemon and white is the palette; in "Christ Before Pilate", sapphire and rose madder.

These religious compositions bring me to the notes on which I should like to conclude—Charlot as a religious draughtsman and Charlot as a muralist. It seems to me that, judging from his series of *tondi* representing six of the Christian mysteries of the rosary, he lays himself open to the criticism of a lack of religious sensitivity. He ha̤ obtained powerful artistic effect through beautifully fused palettes and through the force of original directive lines and foreshortenings. But his paintings of Mexican Indians showed the same virtues; only to the faces he added the characterful notes of human feeling. He does not really do this to the faces of the characters in his scriptural scenes. They are strangely wooden and unmovable.

But with Charlot as a muralist one is on much more

positive ground. He seems to have an unerring instinct for choosing a canvas and a blocked-out design for carrying well. The canvases he used for painting the six Christian mysteries were not particularly large. They were square in shape. Just inside the frame, on the canvas, he painted, in each case, a black circle and into that the composition went. Yet in the little world created within that circle how much space could Charlot not suggest! It was almost as if we looked at the past through a telescope. It was magnified yet it spread out. If only the paintings could be themselves enlarged and transferred to a large frescoed wall, their effect would be *terrific*.

This, then, is where I prefer to take my leave of Charlot. If he has long life, he cannot fail to achieve a great deal, because his work, except for the strictures made, is instinct with human feeling which he expresses in original modern design and color. To his sense of human drama is added a profound sense of the history as well as the painting of the past. A bright augury for any painter!

CONCLUSION

CONCLUSION

A DUTCHMAN, a half-Peruvian-Indian, four Frenchmen, and three Americans are the masters of modern art composing this book. Some people will probably wonder why the list does not contain various other painters. Naturally I have quite purposely omitted them. Picasso, for instance, will be missed. Although there is no gainsaying that he is an important and very prominent modern painter whose versatility is perhaps greater than that of any other painter today, his output is radically weakened by many unpleasing, futile, and, as we can see now, inartistic phases. As Ozenfant, himself in the advance guard of modern painters, says, since 1914 Picasso's work is

> "besprinkled with dots, spots, squiggles, charmingly pretty or aggressive color, and paradoxical forms. His grand manner degenerates into intriguing mannerisms. His inventions are at times charming and ingenious, but they are the expression of a trivial ideal of sensation and feeling: they stop short suddenly."

In other words, Picasso has a feverish power of invention, but his inability to progress in his art has left him, in the final analysis, a great improviser rather than a great creative painter.

Omission may be felt of painters like Lurçat, Masson, Kokoschka, de Segonzac, Vlaminck, Dufy, Rousseau, Riv-

117

era, or others. I shall be told that I ought not to have overlooked Bellows, Burchfield, Kent, Davies, Brook, Benton, Karfiol, Speicher, Sheeler, and Sterne, a few among the many Americans.

My answer, however, will be the same for each omission. The merit of such painters is considerable or I should not have mentioned them here. But we are not out for acceptable painters or those who are specialists or those who have facility in many lines or those whose purpose it is to surprise and shock but we are out to find modern greatness.

The painters whom these pages laud play their often difficult notes in a clarion, unmistakable style. They see beauty in a certain way and it becomes unique for everybody else. They are prophets of that way. In their own selection and emphasis of beauty—for beauty is a certain selection and emphasis as well as prophecy—they are absolutely original. Other painters may do as much, but other painters do not have that greatness in both style and statement which is the hallmark of genius.